Stitched Textiles
Nature

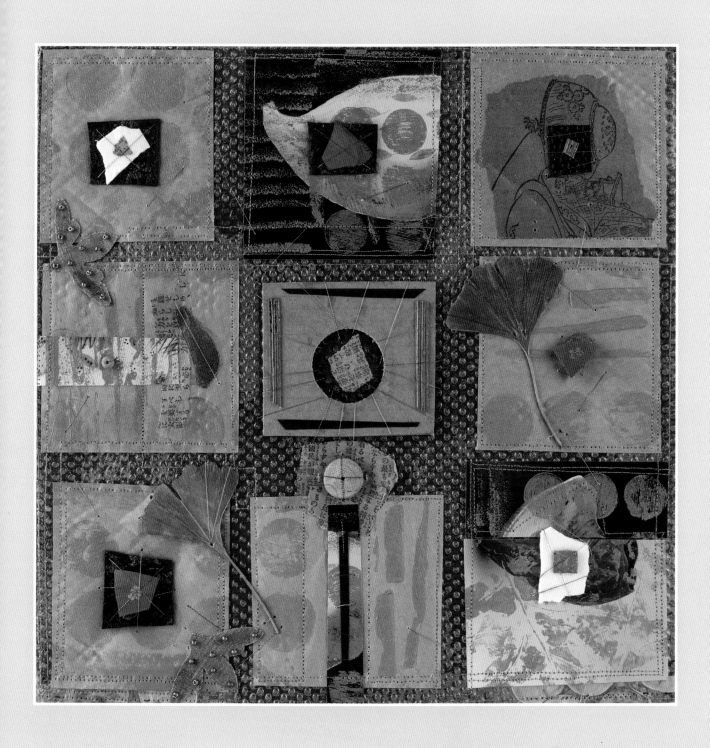

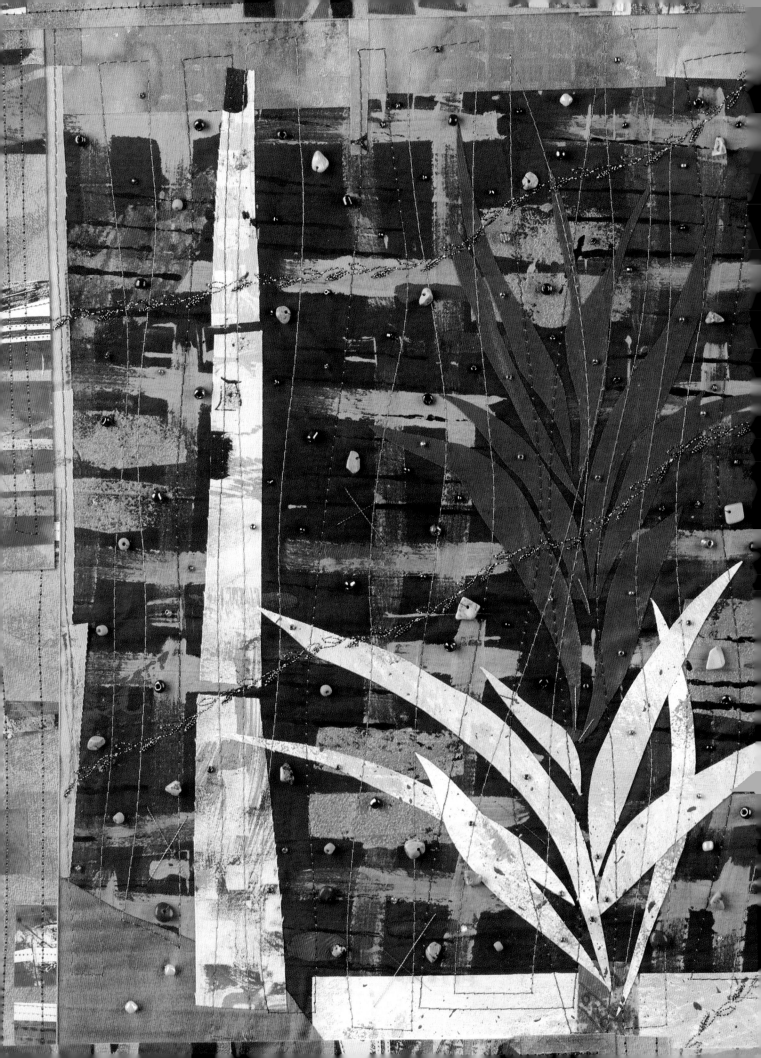

Stitched Textiles
Nature

Stephanie Redfern

Search Press

First published in Great Britain 2018

Search Press Limited
Wellwood, North Farm Road,
Tunbridge Wells, Kent TN2 3DR

ISBN: 978-1-78221-452-6

Suppliers
If you have difficulty in obtaining
any of the materials or equipment
mentioned in this book, then please
visit the Search Press website for
details of suppliers:
www.searchpress.com

You are invited to visit the author's
website: www.stephanieredfern.co.uk

Printed in China
through Asia Pacific Offset

Dedication

To my parents.

Acknowledgements

Thank you to the charming people at Search Press, particularly
Roz Dace, for affording me the opportunity to write this book,
and my editor, Beth Harwood, for working incredibly hard with
my material. Many thanks also to Paul Bricknell for his wonderful
photographs and good company during the photography shoot.

I also want to thank my husband, Phil Redfern, for his multiple
contributions to this project, not least his huge logistical input;
and my daughter, Chloe, for her patience and advice.

Many thanks, too, to Sue Bibby, Julie Ball and Hilary Beattie
for their encouragement and support, and to Trevor Ball for his
logistical help.

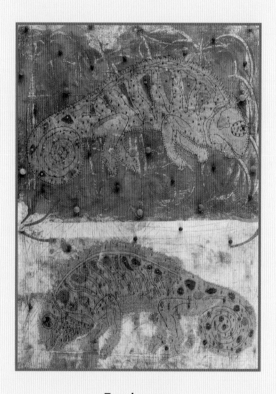

Front cover
Rainforest I – see also page 80.

Page 1
Part of *Gold* series – see also page 45.

Pages 2–3
Night Bloom, from artists' book, *The Rainforest Leaves*.

Pages 4–5
Sea Fossil – see also page 116.

Chameleon.

Winter, Pool, Moon, Tree.

Contents

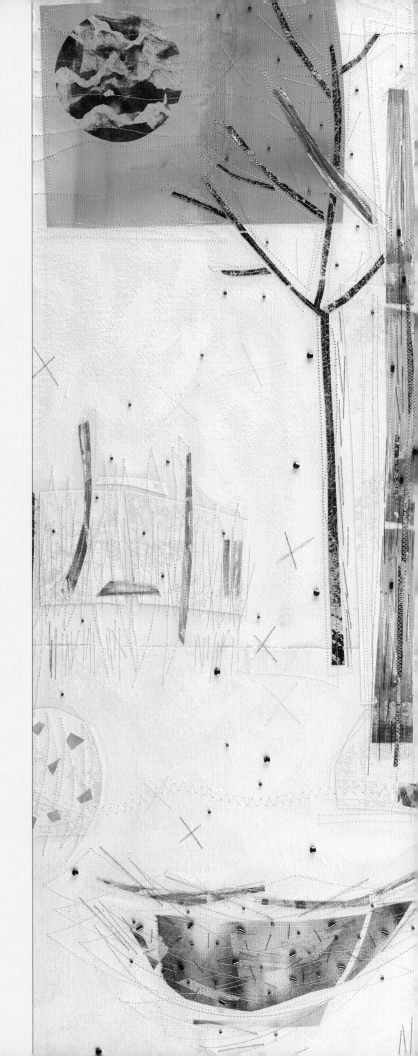

Introduction

For millennia, since humans first started to represent the world around them, the natural world has been the inspiration for myriad paintings, sculptures, designs and illustrations. It is of course inevitable that we record the world in which we live, and that the very system that supports us should have a profound effect upon our art. From the cave art of France, Spain and Indonesia to beautiful and scientifically exact botanical illustrations, from the expressive flower paintings of Vincent van Gogh and Georgia O'Keeffe to the intricate ordered textile designs of William Morris; from architects such as Antonio Gaudi to contemporary environmental artists, we can marvel not only at nature, but how we have interpreted it.

The natural world has provided me with marvellous material and inspiration for my work for many years. With endless visual resources to explore, it is without doubt that nature is a creative well you can dip into endlessly.

Before I moved my artistic practice into stitched textiles I worked with ceramics, making and decorating vessels, sculpture, tiles and jewellery, and the natural world supplied my subject matter using the medium of ceramics for twenty years.

I have moved from one natural history subject to another and indeed back again over my years as an artist. My style has changed and developed, but some subjects – such as beaches, botanical material, birds and the rainforest – continue to inspire me; I find that each time I return to these themes I add more references and design elements to my library of visual resources.

Generally I like to use my own photographs and drawings as the starting point for my work, but will supplement them with other material as necessary. For instance, I love to use the rainforest as a subject, and my inspiration has come from visits to botanical gardens and from researching the creatures of this environment in books and on the internet: I am yet to visit a real rainforest. Visits to natural history museums have also provided a rich vein of images for my own practice.

There is something in nature to inspire everyone, from a forest to a single tree; from the ocean to an intimate study of a shell; the beauty of a single pebble, leaf or a perfect butterfly. Using the resources of the natural world you can produce image-based work, translate your inspirational material into pattern, or realize the abstract potential of your chosen subject.

You don't have to travel far to find wonder: gardens and the suburban landscape can provide all we need, as can a walk in the woods, or time spent exploring a beach. You can enjoy gathering material and making notes of ideas of how to interpret that material from a variety of sources. I find that holidays, outings and walks around the neighbourhood provide plentiful opportunities to take photographs, perhaps make quick sketches and notes, and plan future work.

Whether you are new to working with textiles and multi-media, or more experienced, the natural world will provide you with inspiring subject matter. You can make one-off pieces, or, excitingly, create a series of works based on a subject about which you are passionate. When we are surrounded by such natural abundance it's not difficult to find something to fuel your creative journey; I hope that some of the ideas and projects in this book – alongside the descriptions of how I interpret and develop ideas into finished pieces – will help you on your way.

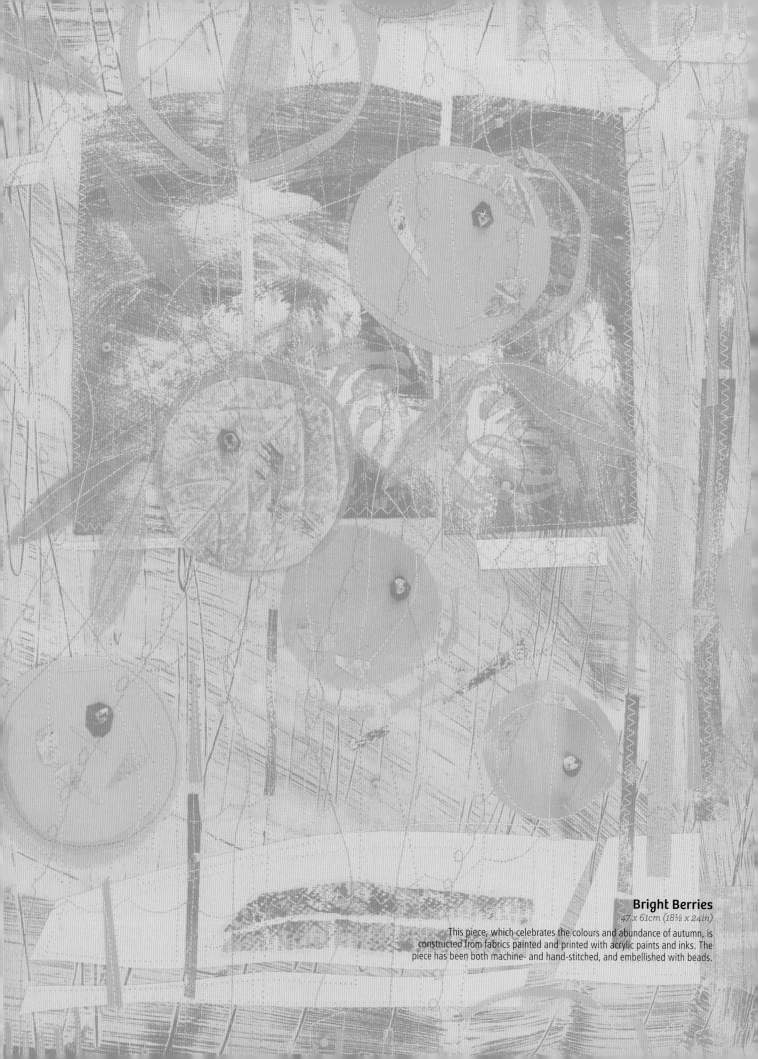

Bright Berries
47 x 61cm (18½ x 24in)

This piece, which celebrates the colours and abundance of autumn, is constructed from fabrics painted and printed with acrylic paints and inks. The piece has been both machine- and hand-stitched, and embellished with beads.

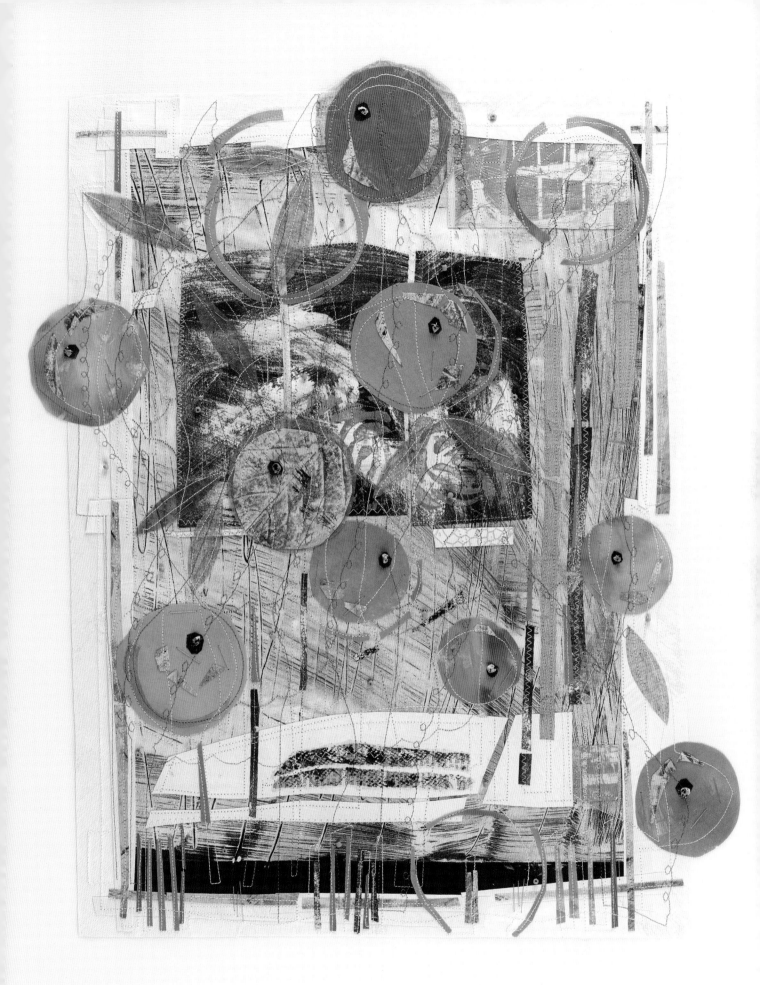

Materials

I describe my work as textile- and mixed-media-based art. I use fabrics that I paint and print myself; commercial fabrics; paper – which is also often painted and printed; digital images; a variety of drawing media; machine- and hand-stitch, and embellishment – usually beads and occasionally found natural objects.

There are many materials available to work and experiment with, and I have tried and tested quite a few of them. I have, however, always indulged my first love of using acrylic paints and inks to produce customized fabrics and papers.

I generally prefer not having vast amounts of materials to work with, fully believing that a natural limitation on what you use aids individual creative development rather than inhibits it. However, feel free to try as many materials as you would like in order to discover the ones that really speak to you. It's also undoubtedly true that trying a new product every so often can really move your work along, and I certainly enjoy introducing new materials into my practice. On these subsequent pages are my essential materials.

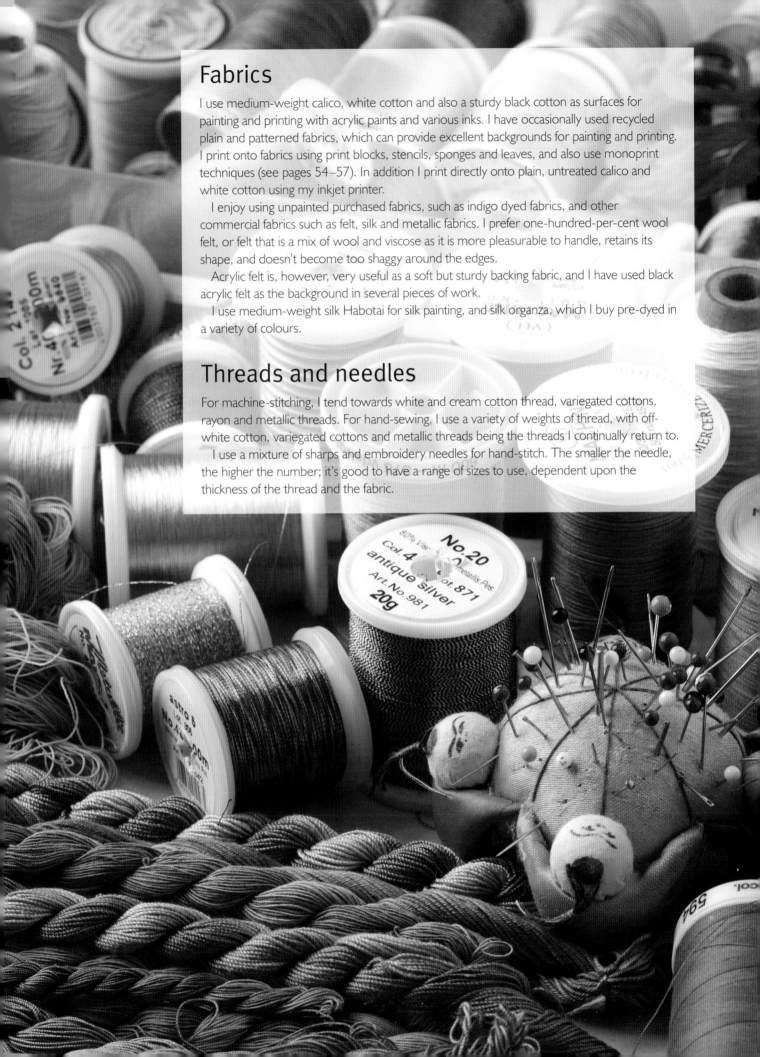

Fabrics

I use medium-weight calico, white cotton and also a sturdy black cotton as surfaces for painting and printing with acrylic paints and various inks. I have occasionally used recycled plain and patterned fabrics, which can provide excellent backgrounds for painting and printing. I print onto fabrics using print blocks, stencils, sponges and leaves, and also use monoprint techniques (see pages 54–57). In addition I print directly onto plain, untreated calico and white cotton using my inkjet printer.

I enjoy using unpainted purchased fabrics, such as indigo dyed fabrics, and other commercial fabrics such as felt, silk and metallic fabrics. I prefer one-hundred-per-cent wool felt, or felt that is a mix of wool and viscose as it is more pleasurable to handle, retains its shape, and doesn't become too shaggy around the edges.

Acrylic felt is, however, very useful as a soft but sturdy backing fabric, and I have used black acrylic felt as the background in several pieces of work.

I use medium-weight silk Habotai for silk painting, and silk organza, which I buy pre-dyed in a variety of colours.

Threads and needles

For machine-stitching, I tend towards white and cream cotton thread, variegated cottons, rayon and metallic threads. For hand-sewing, I use a variety of weights of thread, with off-white cotton, variegated cottons and metallic threads being the threads I continually return to.

I use a mixture of sharps and embroidery needles for hand-stitch. The smaller the needle, the higher the number; it's good to have a range of sizes to use, dependent upon the thickness of the thread and the fabric.

Papers

I paint and print on a range of papers to use in collage work, which may be used as backgrounds in finished stitched pieces, or used in my sketchbooks and on my design and ideas sheets. I find a good range of printed and painted papers entirely inspiring to dip into when making work or sketchbook pages and when moving a design idea on from early sketches and observational drawings towards designs that may turn into finished pieces.

I paint cartridge paper, watercolour paper and Khadi paper using acrylic paints and various inks. I also print on these papers using print blocks, stencils, sponges and leaves, and make monoprints on paper (see pages 54–57). Khadi paper is recycled, one hundred per cent cotton rag paper, made in India. It is available in several weights: I prefer the 320gsm (140lb) weight to paint and to print on. Khadi paper is available in many shapes and sizes too.

I also use a small collection of mixed commercial papers, in different colours and textures: my collection of pages from magazines and newspapers is perfect for experimental collage work.

I particularly enjoy using digitally printed papers in collage and design work. I use my own photographs, and images of my work to create digital prints, sometimes having previously altered them using the filters available in digital software packages. I print on Khadi paper, watercolour paper, cartridge paper, acetate, tracing paper and canvas paper, buying the latter in packs of fifty 220gsm (135lb) weight sheets.

Sketchbooks and sketching papers

I confess I am not particularly organized when it comes to sketchbooks. I don't have a neat library of matching sketchbooks, and not one of my sketchbooks has a lovely handmade cover. I have a tendency to buy a sketchbook if it excites me, either with its shape, size or quality of paper. I find that a new sketchbook inspires me and leads me in new directions, especially if it is an interesting shape, such as a long landscape or good-sized square pad. I like the paper to be fairly heavyweight, at least 140gsm (95lb) so that it can withstand the use of ink, water and glue. I like to draw and paint on other papers too, particularly good-quality watercolour paper: 300gsm (140lb) and 638gsm (300lb) cold-pressed paper, which have a subtle texture. Cartridge paper is also very useful when sketching, once again in a heavier weight of 220gsm (135lb). I use A2-size cartridge paper – 42 x 59.4cm (16½ x 23½in) – for my design and idea sheets (see pages 30–31).

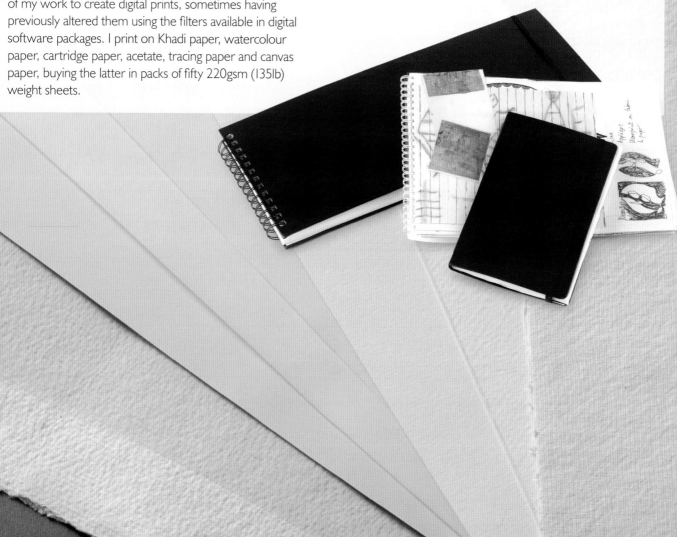

Embellishments

I add some sort of embellishment to most of my work, seeing this addition as part of the overall design of the piece. I tend towards beads, preferably small glass beads and gemstone chip beads; I use only beads that my needle will fit through, since I find that beading needles bend easily when moving through more awkward layers of fabric.

I have also used wood, pebbles and metal as embellishment: tomato paste tubes, for instance, are a good, cheap source of metal; when flattened out this metal is easy to cut with scissors; and can be machine-stitched with care. Thin metal can also be hand-stitched: punch holes in the metal first with a bradawl supported by a sheet of foam board (see page 42).

Other ideas for embellishment include dried leaves and pieces of bark, and found items such as interesting pieces of plastic and papers – for example, corrugated paper and printed papers. I have also laminated natural objects for embellishment – including pods of Honesty, as seen in the *Gold* series of works on page 45. Old photographs can introduce interesting elements into a piece, as well as old jewellery, watches and other ephemera. I have also used a variety of small ceramic pieces: terracotta from a flowerpot, or porcelain. These do require careful handling due to the possibility of sharp edges.

If you haven't yet tried adding mixed media to your work as an embellishment, start building up a collection of interesting found materials that you can add to your work as required.

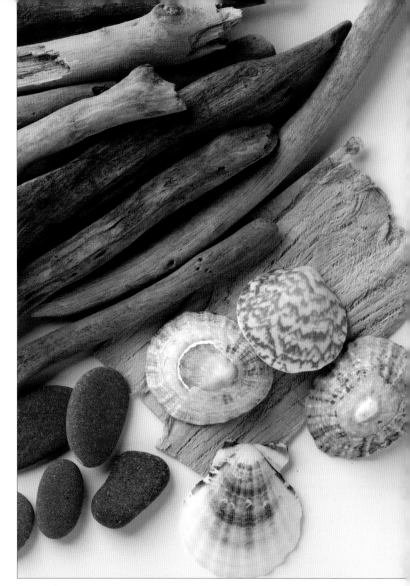

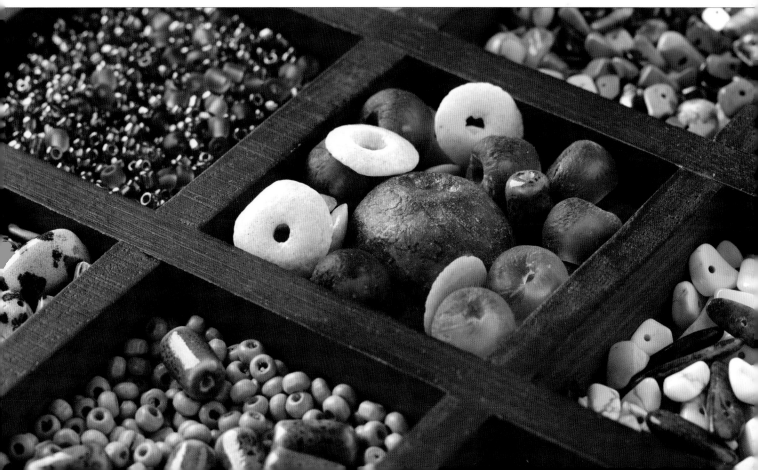

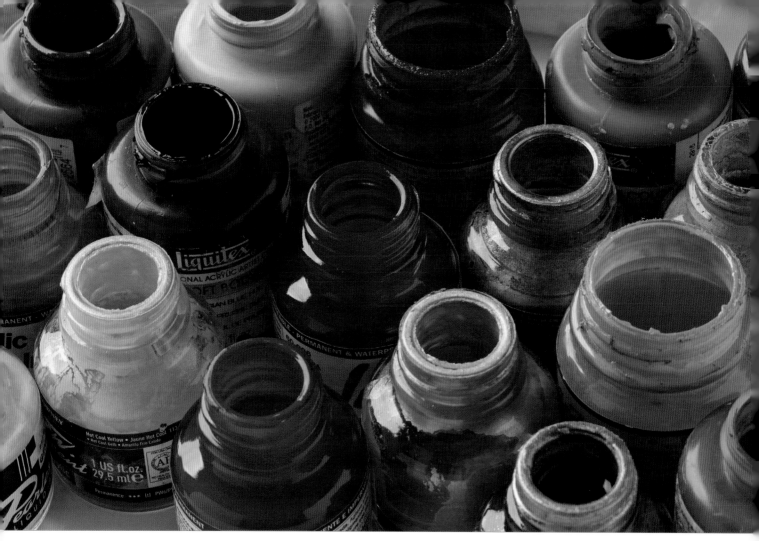

Acrylic paints and inks

I have coloured fabrics and paper with acrylic paints and inks for many years. Acrylic paints and inks are readily available, versatile and easy to use. Their light-fast properties are also very good, and on fabric as well as paper acrylic paints can be used to produce a range of appearances, from impasto to watercolour effects. See pages 46–57 for the process and practice of painting on fabric to form backgrounds and elements for your own work.

I use a range of acrylic paints, from the more expensive makes to the very cheap and cheerful. They all perform well on fabrics in different ways: cheaper paints are less saturated and their colours are less intense and rich than the more expensive paints, but the cheaper brands can be useful for covering larger areas of fabrics and papers, with more expensive colours added in smaller amounts on top.

Acrylic paints come in different consistencies, from the freer-flowing soft body paints to the more buttery, heavy-body paints, which hold brushstrokes and can create more sculptural effects when used undiluted.

When you are looking into purchasing acrylic paints, go for a mid-price range to start with, and add in a mix of cheap and expensive paints as you wish. Metallic acrylics are also very useful as they can add an attractive sheen to your surface.

I use a variety of acrylic inks, including metallic and pearlescent colours. The inks can be very intense, and whether they are used neat or watered down they introduce brilliant, translucent colour onto fabrics and papers. For printing, both acrylic paint and acrylic ink work well, although paint can dry quite quickly, especially when being used for making monoprints (see pages 54–57).

Opposite

Beach III, Spring Storm
36 x 53cm (14¼ x 20¾in)

This beach-themed piece was based on my own photographs of the peat remains of ancient forests on the Welsh coast, which were submerged many thousands of years ago. The rich vocabulary of the eroded shapes of the forest could provide me with inspiration for a very long time.

The picture also features headlands and cliffs, a clouded moon and some fairly invigorating weather, described by some bold streaks of flung acrylic ink in the top right-hand corner. The piece is truly multi-media, made from painted and printed calico, commercial fabric and black cotton, painted maps, machine- and hand-stitch, and beads.

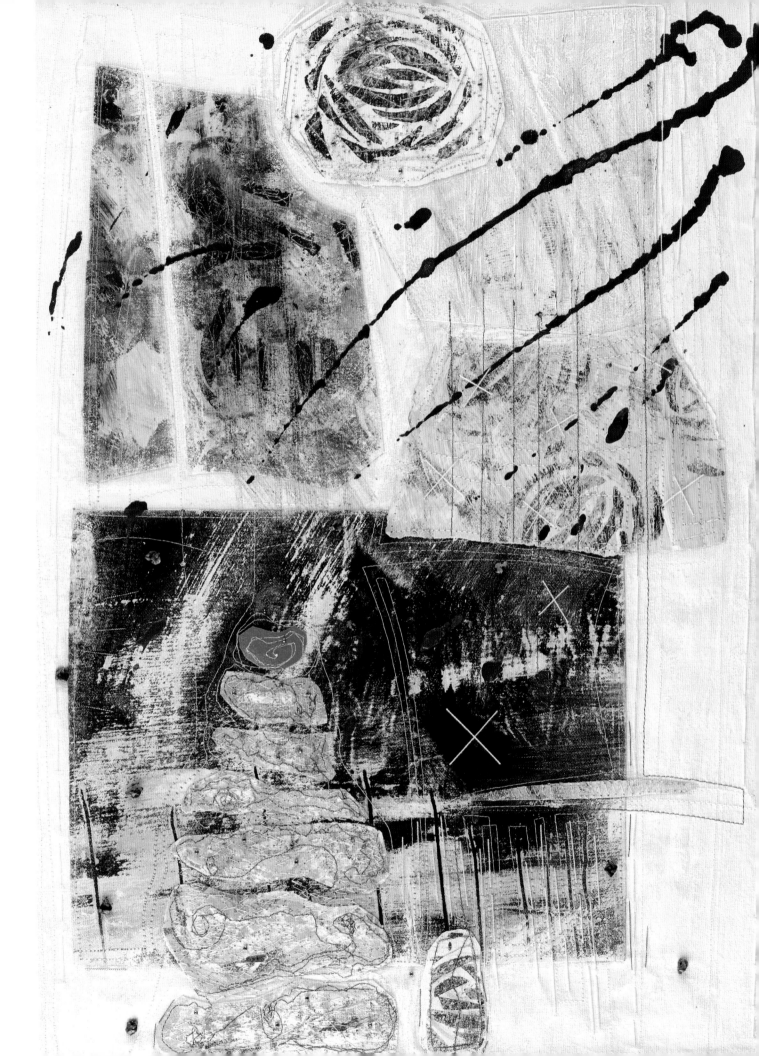

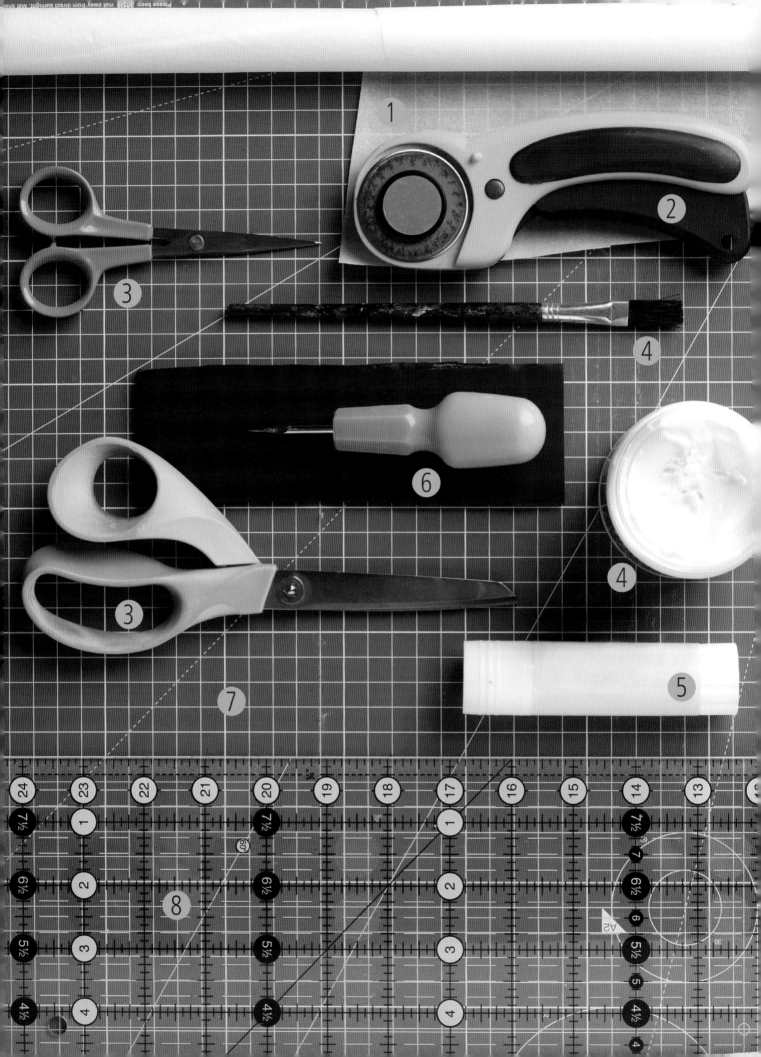

Equipment

The equipment in the picture opposite is useful when cutting up and compiling textiles and embellishments:

1 Fusible web Fusible web is something I use constantly, as I like my work to be firmly in place before I start to stitch. I use paper-backed fusible web on the back of largish sheets of fabric, which means that I can transfer designs onto the back, ready to cut out.

2 Rotary cutter I use my rotary cutter to cut fabric to size, to cut strips of fabric and to trim edges after stitching and before finishing. I also use a rotary cutter to trim paper. It is best to have one cutter for paper and one for fabric. I use the larger blade, meant to cut straight lines or gentle curves. The blade automatically moves into a safe position when the cutter not in use.

3 Scissors of different sizes For cutting and edging papers, fabrics and other found materials such as soft metals.

4 Glue and applicator brush I like to use Liquitex heavy-body gel medium as a glue for heavier papers: it's very strong, doesn't discolour and causes very little cockling on the paper. It is quite expensive but lasts a long time.

5 Glue stick This is ideal for sticking lighter-weight papers and also certain fabrics.

6 Bradawl and foam board Use a sharpened bradawl for making holes prior to stitching thick pieces of work; rest a small piece of foam board underneath the fabric or paper to protect your work surface.

7 Cutting mat A flexible cutting mat is essential for use with a rotary cutter, as it will not dull, or be damaged by, the blade and will also protect your work surface. My mat is 90 x 60cm (36 x 24in), which I find ideal for both small and large pieces of fabric and paper.

8 Non-slip quilting ruler A see-through, non-slip quilting ruler is also essential for use with the rotary cutter and cutting mat, as it will not slip on fabric, paper or the mat, and its transparency helps with positioning and cutting. Quilting rulers are strong enough to withstand a cutting blade. Mine measures 62.5 x 21.5cm (24½ x 8½in) but quilting rulers are available in a variety of sizes and shapes.

My sewing machine

I use a small computerized sewing machine, which I bought after years of stitching all my work by hand. I use mostly straight stitches of various lengths, but also enjoy using some of the decorative stitches that are pre-programmed into the machine.

If your machine struggles to stitch with metallic threads, try using a special metallic thread needle: I use 90s or 100s needles to sew through thicker materials as these needles can take the pressure. I find that metallic threads behave themselves too with these needles, but it does depend upon the capabilities of your particular machine.

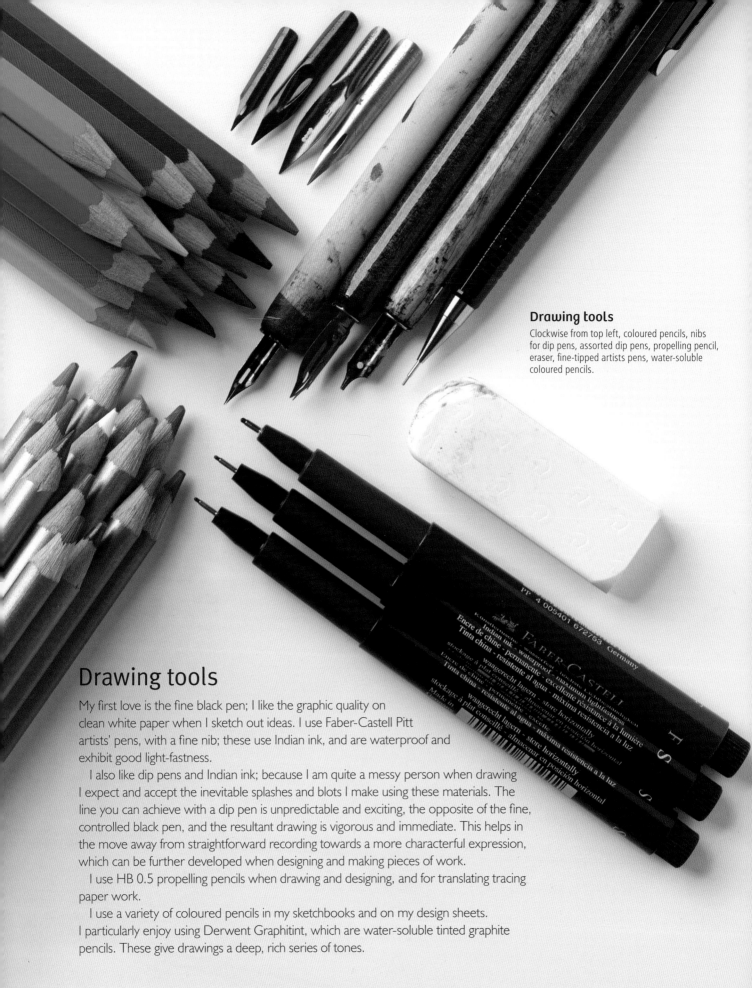

Drawing tools

Clockwise from top left, coloured pencils, nibs for dip pens, assorted dip pens, propelling pencil, eraser, fine-tipped artists pens, water-soluble coloured pencils.

Drawing tools

My first love is the fine black pen; I like the graphic quality on clean white paper when I sketch out ideas. I use Faber-Castell Pitt artists' pens, with a fine nib; these use Indian ink, and are waterproof and exhibit good light-fastness.

I also like dip pens and Indian ink; because I am quite a messy person when drawing I expect and accept the inevitable splashes and blots I make using these materials. The line you can achieve with a dip pen is unpredictable and exciting, the opposite of the fine, controlled black pen, and the resultant drawing is vigorous and immediate. This helps in the move away from straightforward recording towards a more characterful expression, which can be further developed when designing and making pieces of work.

I use HB 0.5 propelling pencils when drawing and designing, and for translating tracing paper work.

I use a variety of coloured pencils in my sketchbooks and on my design sheets. I particularly enjoy using Derwent Graphitint, which are water-soluble tinted graphite pencils. These give drawings a deep, rich series of tones.

Painting tools

I use a range of brushes, from the more expensive brushes for painting and design work, to household paintbrushes, which are ideal for painting fabric and paper. Old toothbrushes are perfect for subtle flicked and sprayed effects, and I use sponges for stippling and printing, and for use with stencils. Sponge rollers and brayers are also useful for laying down paint when I am creating a monoprint (see pages 54–57).

Palettes

You do not need to spend a lot of money on an expensive paint palette; plastic plates and recycled plastic containers work perfectly well.

Painting tools

From top left to right: 5cm (2in) brayer; sponge roller; sponge; 15cm (6in) brayer; toothbrush; size 4 fan blender – synthetic bristle; size 1 round brush – synthetic bristle; flat ½ inch bristle brush; size 20 round brush – synthetic bristle; size 8 flat bristle; size 6 flat wash brush – synthetic bristle; household paintbrush (50mm); paint palette and household paintbrush (25mm).

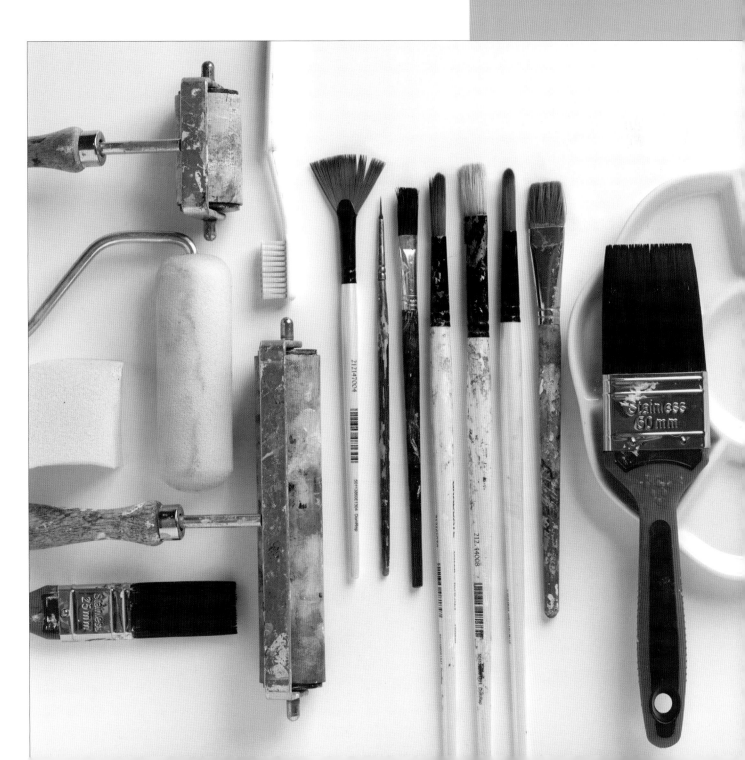

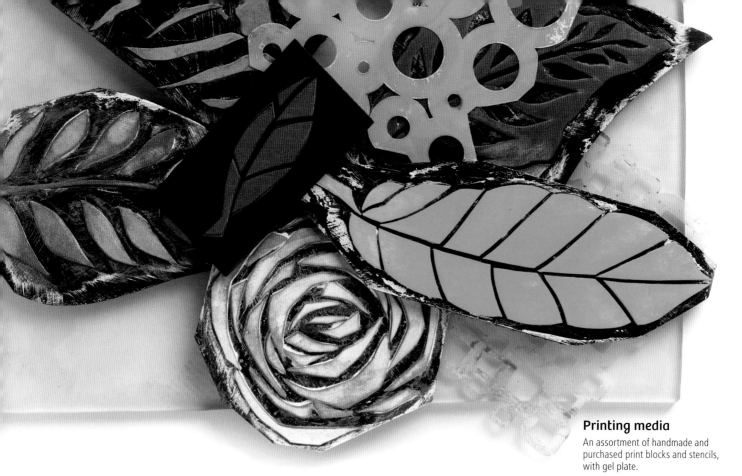

Printing media
An assortment of handmade and
purchased print blocks and stencils,
with gel plate.

Printing media

I use print blocks to add pattern, depth, colour and visual texture to my surfaces. I have made and used many print blocks from thin foam pieces stuck onto a support, and they are surprisingly tough. These can be used for printing fabric and paper with paint and inks.

I love to use leaves and plant material for printing and as stencils. Nature as a resource cannot be beaten, and many of my favourite fabric surfaces have been made using leaf prints.

I also use simple cut and ripped paper shapes as stencils when making monoprints, and I have a couple of purchased acetate stencils too.

Monoprinting materials

Monoprinting produces wonderful effects, and is easy and simple to do at home, to produce one-off prints on fabrics and papers. I use a gel printing plate to make my prints. Gel printing plates are available in a variety of sizes – I use a 30.5 x 35.5cm (12 x 14in) plate. With a mix of simple paper stencils and plant material I can produce prints that inform and suit my work. You can use acrylic sheets as a basis, too; laminated paper also works well.

See pages 54–57 for a step-by-step guide to monoprinting.

Monoprinting
I apply acrylic paint to a gel printing
plate using a brayer.

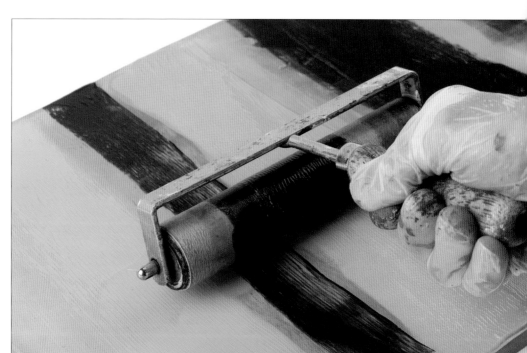

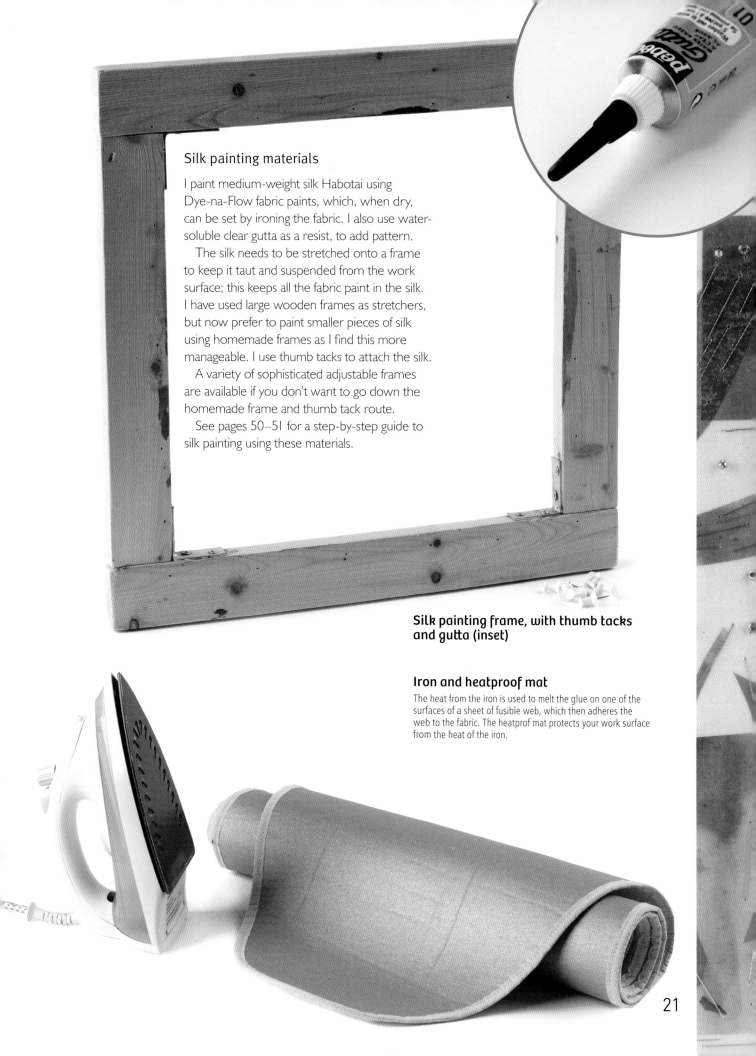

Silk painting materials

I paint medium-weight silk Habotai using Dye-na-Flow fabric paints, which, when dry, can be set by ironing the fabric. I also use water-soluble clear gutta as a resist, to add pattern.

The silk needs to be stretched onto a frame to keep it taut and suspended from the work surface; this keeps all the fabric paint in the silk. I have used large wooden frames as stretchers, but now prefer to paint smaller pieces of silk using homemade frames as I find this more manageable. I use thumb tacks to attach the silk.

A variety of sophisticated adjustable frames are available if you don't want to go down the homemade frame and thumb tack route.

See pages 50–51 for a step-by-step guide to silk painting using these materials.

Silk painting frame, with thumb tacks and gutta (inset)

Iron and heatproof mat

The heat from the iron is used to melt the glue on one of the surfaces of a sheet of fusible web, which then adheres the web to the fabric. The heatprof mat protects your work surface from the heat of the iron.

Design and inspiration

When I want to start a new project, ideas could come from different sources. I might have some new fabric that inspires some work, or I might have a new set of photographs, drawings, or a combination of the two. I might also be working to a theme for an exhibition, which would possibly dictate the subject a little more.

I have returned to certain themes many times, particularly the rainforest, botany and bird life. Choosing a theme to work with is the basis of establishing a personal style. Most of us have something that interests us, something that we would like to explore further. Use whatever comes naturally; don't overcomplicate your initial ideas worrying that what you want to work with may not be good enough; it will be.

If you are new to designing and making your own stitched textiles, all you have to remember is that there are no rules; you can work in any way you wish. This sounds simple, but try putting this into practice; you simply do as you wish rather than worrying that there is a right way to do things. It is also very true that the more pieces you make, the more your confidence will grow; you will then start to find your voice and your personal style.

Choosing a theme

If you are searching for a theme, something as simple as a walk in your neighbourhood with your camera, or whatever you use to take images, may afford a lot of material. Needless to say, holidays and special trips and visits to specific destinations are also valuable for collecting resources. The beach, forests, gardens and natural history museums are my favourite destinations. I start to develop new ideas by gathering information, which means, to me, a camera, books, the computer, sketchbooks and the above-mentioned visit or walk, if necessary.

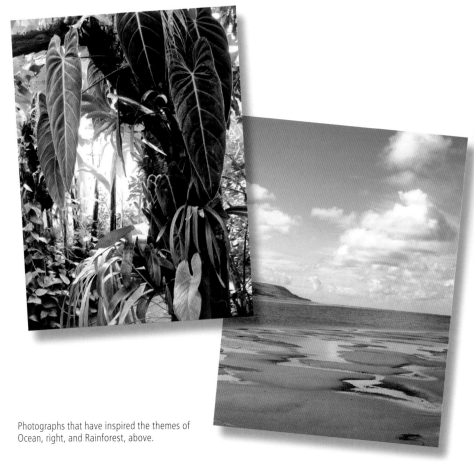

Photographs that have inspired the themes of Ocean, right, and Rainforest, above.

Taking reference photographs

Drawing from photographs suits my design process perfectly, as I find I am able to isolate and develop certain elements from within an image. I try to use my own photographs as reference material, but occasionally I need to source other photographers' images, such as of tropical birds or exotic animals, to which I have little to no access.

Collating your own library of visual resources is a perfect way to begin stimulating your ideas and developing your work and your style. Digital photography is a wonderful resource as we can store quantities of visual stimuli on computers, tablets and other devices, which can then be altered digitally and printed off as necessary.

When starting a project I scroll through my images, and choose those that excite me most. The photographs in question may not be wonderful compositions; but it is the information they hold that is important to me. I then print off a selection of these photographs as I find it easier to draw and design from hard copies. I glue the prints into my sketchbooks and onto my design sheets (see pages 30–31). Any leftover prints I file away for later use, or use as material in my collages.

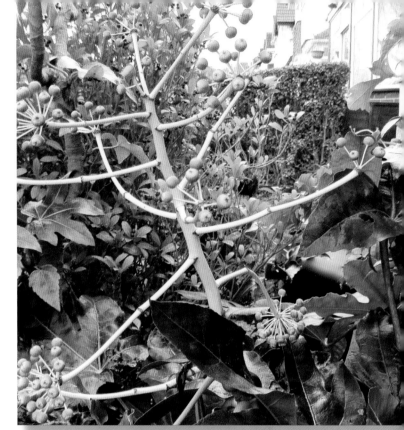

Below, one of my sketchbook pages, inspired in part by the photograph, above right.

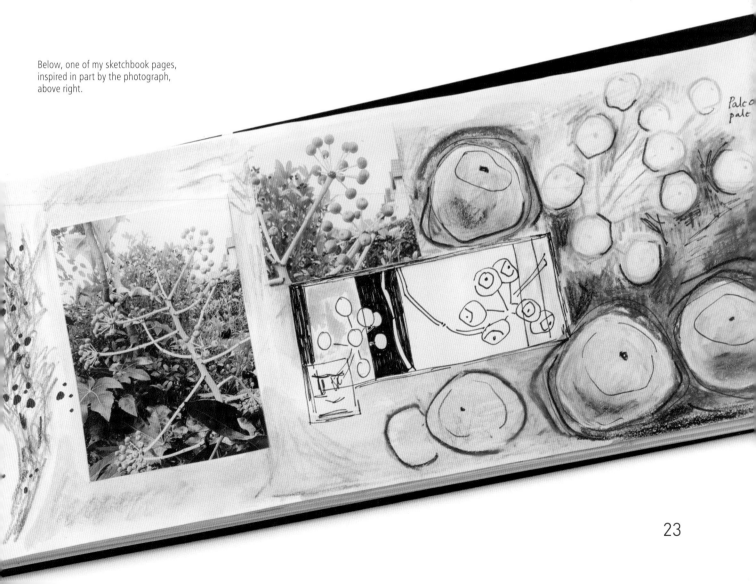

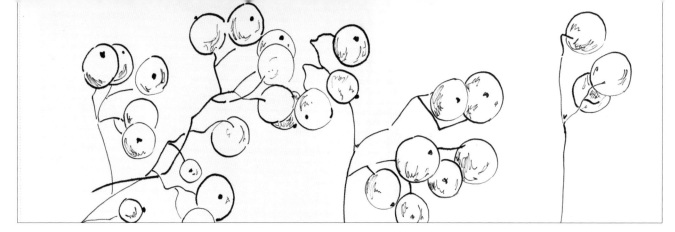

Drawing

Choosing to draw a living thing, such as a plant, will teach you a great deal about its structure and character, and although I have made many drawings in my time, it still amazes me how much can be learned from close observation.

This process can, however, be a frightening prospect for people who are not confident with their drawing skills. I would only say that it doesn't matter how accomplished an artist you are, or what your style of drawing is; the main thing is to have a go at getting down some information and using that in the development of your work. I also find that as I start to draw, the ideas begin to flow in relation to how the piece or pieces of work I am planning to make may develop.

My drawing style has changed over the years. I used to make tight, detailed observational drawings. Now my drawing is looser and more expressive. I still make accurate drawings when necessary, for example, of specific birds and animals, when shape and pattern need to be recorded as accurately as possible.

The more drawing you do, the better you will become, although that need not be the objective. Think of the process as compiling a visual shopping list. Start with simple pencil drawings, then try using a mix of media; I like to use a combination of materials in my sketchbooks to record and develop ideas, to move them along and loosen them up. I use a mix of pens, pencils and occasionally print blocks on my pages, enjoying the freedom and the serendipitous surprises that occur when you employ mixed media.

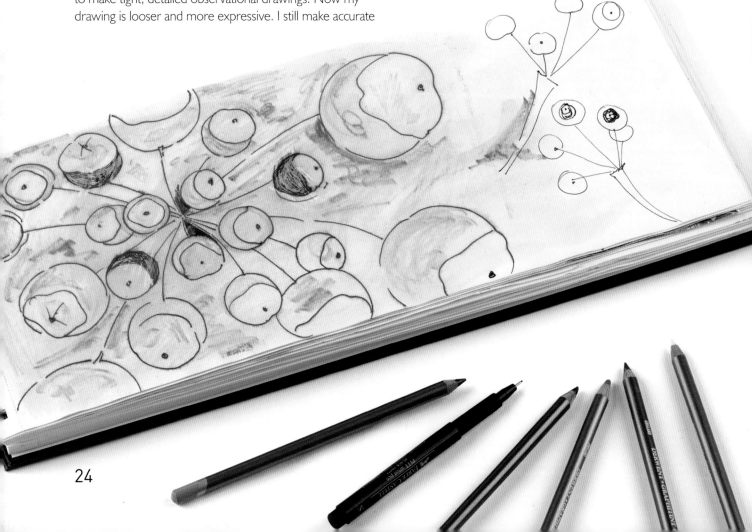

24

Isolating the elements

Starting with a couple of photographs, usually no more than three, I isolate a small number of elements from the image, and draw them. I use a mix of pencil, pen and coloured pencils, but you can use whatever you like. This practice teaches me about the form, shape and structure of the subject. More information can be recorded when working closely from life, and this is also something I do. However, I find that working from a photograph is less inhibiting, and my drawings are freer and, to me, more interesting and vital. A photograph can also introduce possible ideas for quirky layouts, and it is also easier to isolate areas of the image to develop. Even if you want to use a photograph as it is, you may still need to isolate some emphatic key elements. At this stage I may also sketch a few compositional ideas as they occur to me, as you can see in the second drawing shown below.

These initial sketchbook drawings are from a photograph of my garden. I was attracted to the pale berries and stems and wanted to make them into a piece of work.

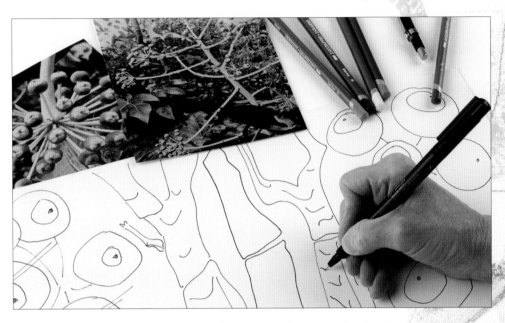

When I have as many elements as I need, I trace or photocopy the drawings, so that I can cut out the shapes to use as pattern pieces if necessary, saving the original drawings as master copies for future use.

Designs can be further stylized using this method, moving away from the naturalistic to the more abstract. This particular design is developed into a finished work on pages 58–65.

25

Using a sketchbook

One of the best ways to start projects is to have a sketchbook. Some people like to colour the pages with ink or paint to take away the fear of contemplating a perfect white sheet of paper. That's a great idea, one which I have happily used here, in my rainforest sketchbook. You can also use sheets of paper, large or small, to collect ideas, notes and sketches. They can be collated into a sketchpad or pinned to a noticeboard or design wall so you can see all your ideas at once.

I make lists of ideas in my sketchbooks, notes of how I may like to use my resources, jottings about fabrics and prints, other artworks I may have seen at exhibitions, in books, television programmes, films, websites, blogs and plays that have had an impact upon me. Not everything will be used, but sometimes it is the smallest thing that triggers something substantial. You can also make files on a computer, tablet or other device to collect your thoughts, and also use digital drawing. I do this too, but inevitably these thoughts and ideas will be transferred to the bulging sketchbook.

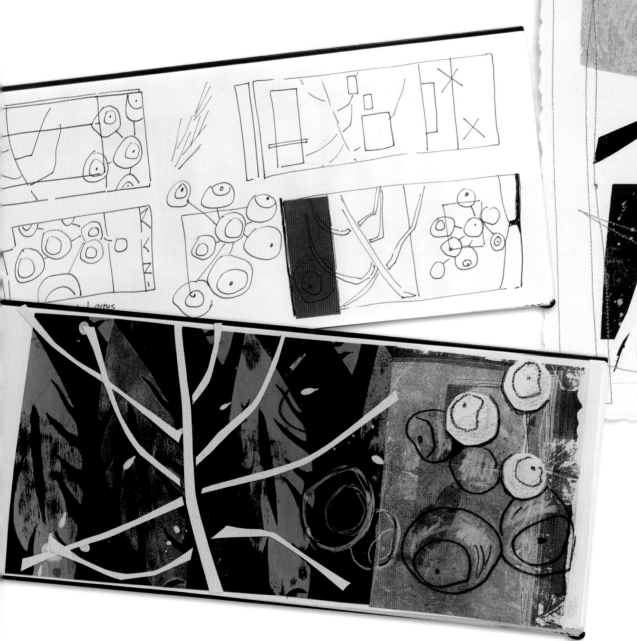

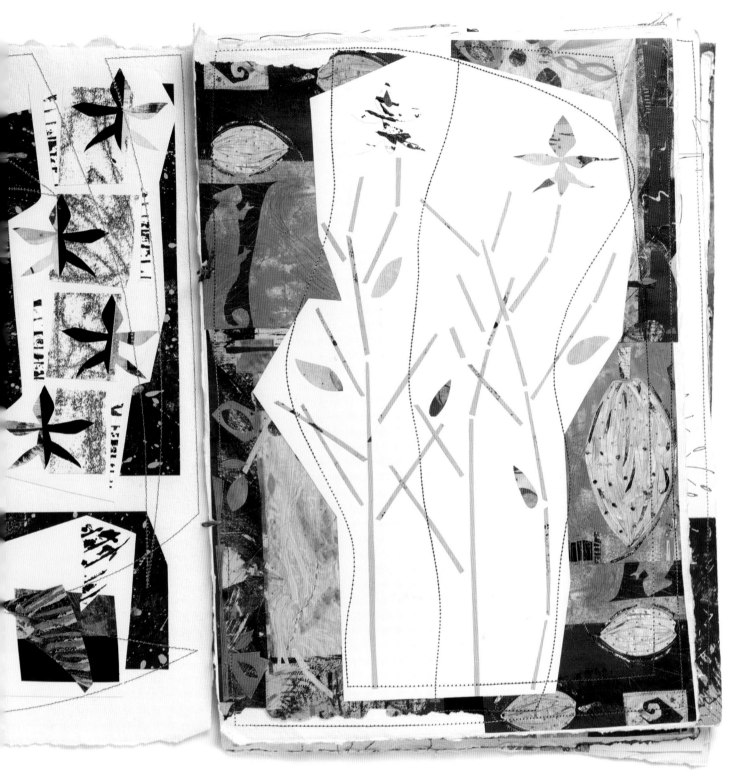

In the pages of the sketchbook above – the rainforest sketchbook – I have enjoyed using a variety of approaches to collect ideas and possibilities for future work. I have painted and printed Khadi paper, and bound the finished pages loosely together to make a lively, vigorous and highly colourful book. The rainforest sketchbook contains the photographs that initially inspired the theme; ideas for the development of the theme; collage in mixed papers, and drawings. I have also stitched through the finished pages, which serves to add line and texture and to inform the finished textile pieces.

Pages from my rainforest sketchbook

The rainforest sketchbook grabs and records many ideas from just a small number of photographs, all of which were taken in botanical gardens.

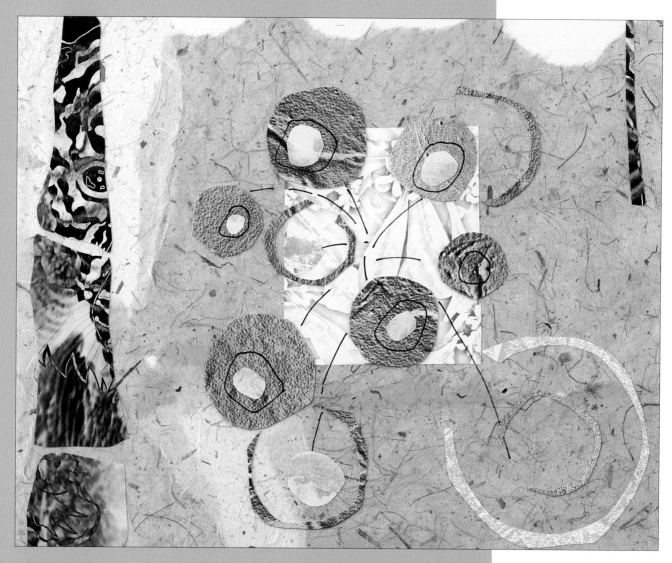

Collage

An absolute necessity for me, after drawing, is using collage. I use a mix of papers in my sketchbooks and on my ideas and design sheets, finding that it can simplify an overwrought design, and also introduce new design directions via the use of shape, juxtaposition, colour and visual texture. Collage enables me to examine the spatial properties of a page, and it follows that this helps considerably towards the development of final pieces. In this instance, collage works as well for me as drawing.

Working with collage will push your ideas into different and sometimes unexpected areas. There is something wonderfully freeing about using papers, scissors and glue, and many people find this less worrisome than drawing. It can also serve to simplify shapes and eliminate fussiness.

Berries I

29.5 x 24.5cm (11½ x 9¾in)

This collage is made from a mix of papers, some examples of which are shown below.

The joy of collage is that it can be used in a freely and experimentally, and also in a more orderly way by using your chosen elements as pattern pieces. In the piece shown above, I have used a mix of papers, photographs and drawing onto collage to increase my repertoire of ideas. I tend to use paper in my collage work, but will also add in mixed media and fabric. In this way a range of potential compositions for finished work can be explored. There is no need to stay with the original colours; you can also use this process to experiment with other colour ideas and combinations. If the papers you choose for your collage really inspire you, you can paint or print some fabrics to use in a stitched piece, or simply treat the collages as experiments in design.

From my collection of initial drawings, collage and sketched compositions I will start to make a decision about my final stitched piece or pieces of work.

Berries II
31 x 23cm (12¼ x 9in)

This collage is also made from a mix of papers and mulberry bark fibre, some examples of which are shown on page 28.

The mulberry bark is also used as a border in *Magnolias*, which can be seen on page 117.

Design and idea sheets

When I want to make a piece of finished textile work I return to my sketchbooks, and decide which of my drawings and collages appeal most. On A2 – 42 x 59.4cm (16½ x 23½in) – sheets of good cartridge paper, I redraw some of my initial sketches and use collage to hone, develop and simplify my approach by producing design and idea sheets. This can also lead to the evolution of more ideas, which is fine, but I find that especially when I intend to work on a series of pieces of work, the clarifying approach of producing the design sheets works well for me. Along with the sketchbooks they contain ideas that can fuel work for a long time, and I do return to them frequently.

However, this is a personal approach, and you certainly don't have to produce design sheets; sketchbooks may be more than enough, and indeed I have made pieces of work straight from the sketchbook page. A painting and printing session beforehand, with your project in mind, can produce papers and fabrics that have a relationship to each other. See pages 46–57 for inspiration on how to paint and print your papers and fabrics.

The creation of a design sheet is not absolutely necessary to your project, but can help with the continuity of your work.

Above and opposite, design sheets developed from my rainforest sketchbook

Colour choices

The natural world affords us a lot of help when deciding upon our colour preferences, and you are free to use colour in any way you choose, quite often without having to make any decision at all, since nature frequently offers us perfect solutions. This is one of the many things that make working with nature so amazing. You are free to use the spectrum the natural world provides, and it is safe to assume that you can successfully work with the colours given. Alternatively, you can change and adapt to form a colour plan to suit your own preferences, and in doing so you will realize that there are no rules when it comes to making art. I tend to work in an intuitive way with colour and indeed design, and this may be an approach you find attractive.

A similar approach can be adopted where nature is cultivated and governed: the colour mix of plants in a summer garden, for example, may prove agreeable to your eye and be exactly what you are searching for to inspire your next piece of work.

The colour palettes we choose for our pieces, whether they are a collection of astonishingly saturated bright hues, a gentle combination of neutral tones or an exercise in black and white, are one of the building blocks that help create our own artistic signature. When I start a project it is quite likely that I will have an idea of the colour scheme I want to use. In my rainforest work, shown on the previous pages, I wanted a combination of black, white, greens, red and pinks. The tones of the colours used varied between the sketchbook, design sheets and finished work, due to the materials used, but the original intent remained.

There are times when your initial colour plan will change according to your materials. When starting a new project, experiment with a collection of painted papers and fabrics, and commercial fabrics, lay them side by side as you edit your choices, and see a surprising new world of colour and design possibilities open up before you.

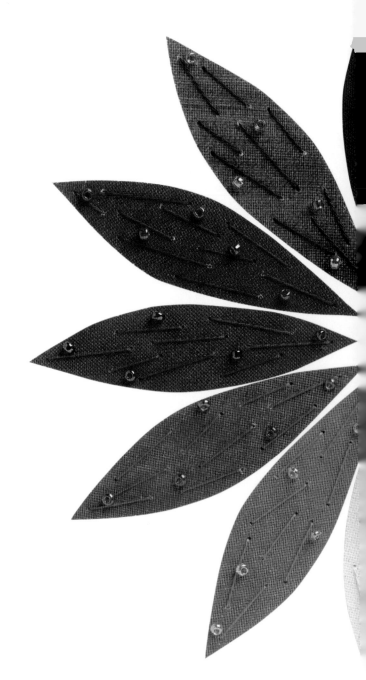

The language of colour

Some of the most useful, and commonly used terms in the lexicon of colour are tint, shade and tone, all of which describe the value of a colour. Value is simply the level of lightness or darkness of a colour.

A tint is a colour with a lighter value, and a shade is a colour with a darker value. Tone describes the lightness or darkness of a colour; in painting this is made by adding white and black, producing a softer version of the original colour.

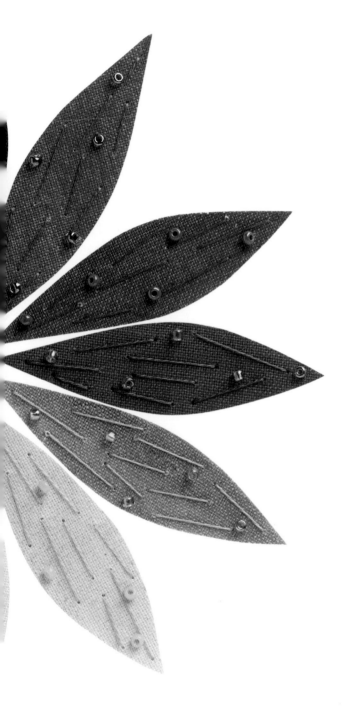

The stitched-textile colour wheel

The science of colour

Although you do not need to be restrained by it, it helps to be aware of some basic colour theory, including the existence of primary, secondary and tertiary colours, and the value terms, tint, tone and shade, mentioned on the previous page.

The pure hues of unadulterated red, blue and yellow are generally accepted as the three primary colours. When, in equal amounts, red and yellow are mixed to produce orange, blue and yellow to produce green, and red and blue to produce violet, we have three secondary colours.

A tertiary colour is produced by mixing a primary colour with its adjacent secondary colour on the colour wheel, in a ratio of 2:1. This will result in additional colours such as red-orange and blue-green, which are subtle hues which are conducive to depicting nature.

Complementary colours

Complementary colours are those colours that sit opposite each other on the colour wheel. Use of these colours makes a balanced composition; many instances of such combinations can be seen in the natural world, but there are also many instances of successful non-complementary colour combinations, so don't be afraid to experiment. Having said that, I do enjoy the combination of reds and greens, and have made several pieces using these colours.

Analogous colours

Analogous colours are next to each other on the colour wheel. Generally a group of three or four of these go together well, forming a pleasant, harmonious colour group. This is a device I have used regularly with my work. If you are uncertain where to start with colour, an exercise using analogous colours could be beneficial.

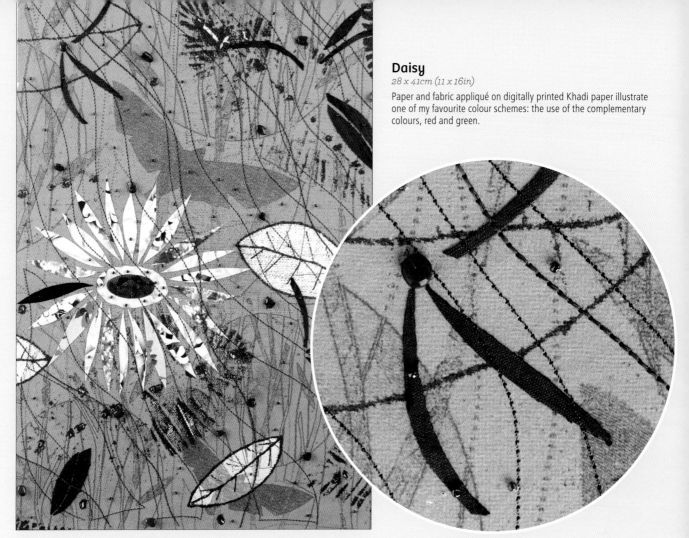

Daisy
28 x 41cm (11 x 16in)

Paper and fabric appliqué on digitally printed Khadi paper illustrate one of my favourite colour schemes: the use of the complementary colours, red and green.

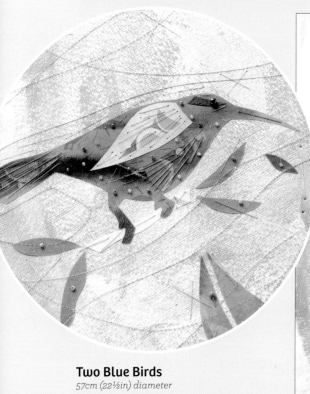

Two Blue Birds
57cm (22½in) diameter

Appliquéd fabrics on Khadi paper. This piece shows the use of an analogous colour scheme.

34

I have also used achromatic schemes frequently in my work. This term means without colour, a palette of black, white and grey. This combination can also work well with the introduction of a bolder colour, as you can see here in my two pieces *Pebbles I* and *Pebbles II*.

Pebbles I and Pebbles II
30 x 30cm (12 x 12in) each
Mixed media on canvas

Warm and cool

Colours can be broadly defined as warm or cool, and how you choose to use and combine the warm or cool materials in your collection can dictate the mood of a piece of work.

 Although your source material may decide your eventual colour choices, experimenting with warm and cool alternatives can be interesting.

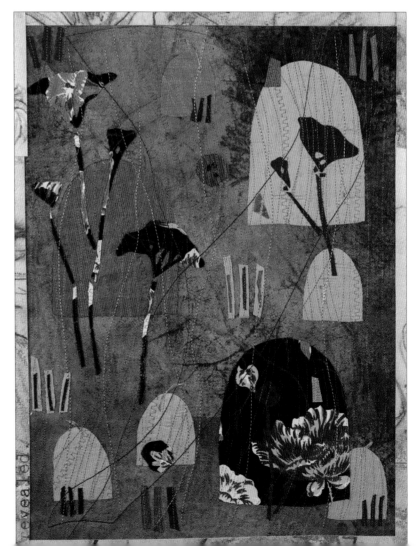

Autumn
37 x 48cm (14½ x 19in)
Warm colours predominate in this piece, for which I used a mix of commercial and painted appliquéd fabrics.

Process and practice

When I conceive a piece of work, I think in layers, with the fabrics and papers being the fundaments of the piece, and the stitching, machine- or hand- or both, being the next layer of necessary line and texture, followed by the important punctuation afforded by the addition of beads and other media.

At the earliest stage of assembly, I find that working with simple shapes in combination with busier fabrics often provides the detail I want; this requires some experimentation, and I go through the same process for every piece I make, large or small.

I look at the ideas and the design work I have completed so far, in relation to the project; I then choose fabrics and sometimes papers that I think I may like to use in the work. I always get out too many 'ingredients' to start with, and slowly they are edited as I try one fabric against another, and choose what I will eventually use. This initial edit is a slow

process, so when you arrive at this stage in your own work don't worry if you seem indecisive; eventually you will arrive at a composition with which you are pleased.

I will invariably cut out a few elements in different fabrics or papers to try against different backgrounds; always try to do this if you can, as it can be amazing what will work for you. Pick out combinations that you would never normally consider, try pattern against pattern for instance, or colour combinations you would never expect to use in a piece.

This sort of experimentation will move your work in new and exciting directions; it is an intuitive way of working, and although I work from my drawings and design sheets, at this stage my work is materials-led. If you think you lack the confidence to work like this, just remember that it is fun, and no one is watching, and that you can do exactly as you like. I also cut out simple elements freehand, and spend time moving them around until I achieve a happy result.

When I start a new project I choose some new pieces from my stock of painted and printed fabrics to use, and add in older materials too. I use heat-transfer adhesive on my fabrics, and sometimes on papers, and iron this onto whole pieces so that I can transfer and cut out elements easily. In this way I use the fabrics as my palette.

I don't have a huge amount of materials, but I have certainly built up a good supply of fabrics that are ready to use, and there have been occasions when simply looking through them has sparked ideas for new work.

It is true to say that the more stitched textile work you do, the more you will build your confidence. If you have a room, a corner, or even simply a table where you can spread out your work and not have to put it away, you will be able to work at it more successfully and keep at it; actually finishing a piece is one of the best learning devices I know.

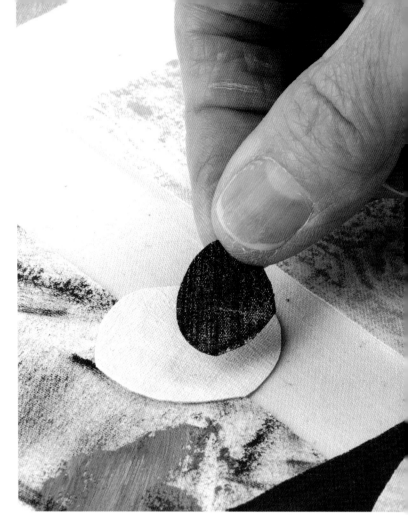

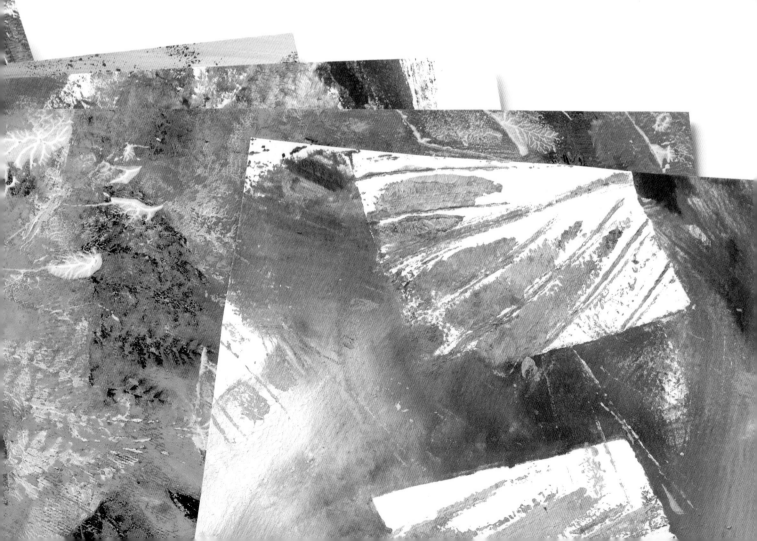

Machine-stitching

A large amount of my work features machine-stitch, which I enjoy for its linear quality, and its ability to introduce a drawn line over the blocks of appliqué already in place. I use it to accentuate and outline the elements, dipping in and out of their outlines, and to add extra details to the composition. I study the laid-down piece before stitching, deciding on the level of machine-stitch to add, and where I would like it to add emphasis, colour and texture.

Machine-stitch can be used sparingly or densely, in a variety of threads and stitches. You may want to think about the use for which your piece is designed; although my work isn't strictly functional, a wall hanging will still need to be well stitched, not only for aesthetic reasons, but also practical ones. A framed piece can be more experimental, since it won't need to support itself in the same way.

I use machine-stitch in most of my artists' books (see pages 82–83) to embellish the pieces of work on the pages, and in the page construction too, as it helps to strengthen them; they have to cope with a lot of wear and tear as they are viewed. Hand-stitch can also be immensely tough, but the amount needed can take much longer to apply, and I do like the mix of both approaches. Some of my work consists of a number of layers, which I prefer to machine-stitch through, with just a smaller amount of hand-stitch applied.

When a piece of work is ready to move onto the machine-stitching stage I enjoy choosing the threads I may want to use. I invariably get out too many, but by spreading some strands across the piece I can judge what really works. I have a fondness for variegated threads; they can subtly combine with the colours of a piece, or add a vibrant range of colour without constantly changing your thread. I often start off with white or cream cotton, adding colour afterwards, and I also like metallic threads to finish a piece. I use 100s needles as I find they are strong enough to go through the layers I sometimes use in my work, and they are also good for handling metallic thread. Topstitch needles are also useful for metallic thread, as they have a large eye.

Change your needle frequently to help your machine function without strain.

Threading your needle
Many machines have automatic needle threaders; or you can thread manually if you wish.

When I start to machine-stitch a piece I always start with straight stitch, having altered the stitch length accordingly. I have the feed dogs raised, to help keep the lines of stitch and curves as neat as possible. This can mean a fair amount of manoeuvering when the piece is being stitched, and a small piece is therefore easier to handle, but if your machine can reverse-stitch this can be helpful when tackling a larger piece.

I may then go on to use one of the programmed decorative stitches that my machine offers.

I rarely use free machine-stitching, unless I occasionally want a scribbled or densely stitched area in a piece of work.

If your machine offers a range of stitches you can experiment with them on swatches of fabric to build a personal library of samples. I like to use felt for this exercise, as it is easy to use and the stitches are clear to see. I experiment, too, with changing the stitch size and using some stitches to build texture.

Choosing your own stitch preferences and threads and using them in conjunction with painted, printed and commercial fabrics from your collection will help towards building your own style.

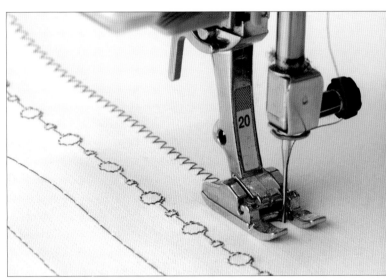

A variety of machine-stitch samples

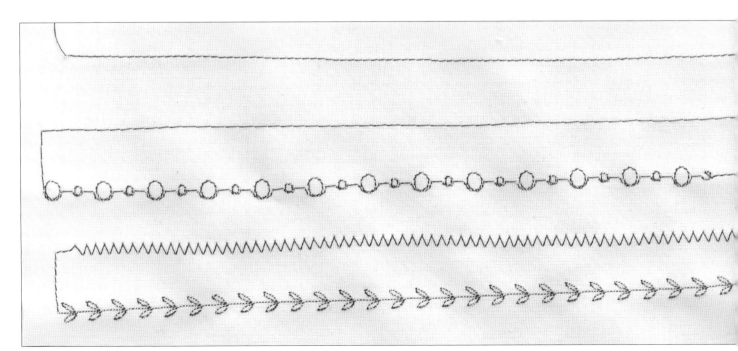

Hand-stitching

The hand-stitch stage is something I look forward to; the piece moves from the energetic activity of machine-stitching to the relative calm of hand-stitching. Whilst I do like to see the effects produced by a mix of machine- and hand-stitching in my work, I am thrilled if a piece of work can be exclusively stitched by hand.

After the appliqué and machine-stitch stages, I hand-stitch my work to add more detail and texture to a piece. Hand-stitch can be very expressive, taking charge of a piece of work, or it can simply add subtle marks to enhance, and indeed it can work on many levels with the combination of these approaches.

Hand-stitching can be worked with a variety of threads: I like to use a crochet cotton, variegated cotton hand-stitching threads, and metallic threads as they meet my needs, but it is always worth experimenting, trying new threads and bolder, or quieter, approaches to your stitching.

You will gain confidence in choosing those threads that really enhance your work; new ideas will also evolve as you try different thicknesses and types of thread.

Colour choice, discussed on pages 32–33, is important and fun to explore. Using a similar colour to a background for instance adds subtle texture, and using a strong contrasting colour can considerably change the character of a piece.

A piece of work that you are hand-stitching can travel anywhere with you, so that in a spare moment you can reward yourself with a little restorative stitching.

Having said that, some of the hand-stitching I have done has been through several layers of painted cloth, mixed media and paper, and I have to use a sharp bradawl to make the holes first (see page 42). This approach may be difficult at times, and far from contemplative, but it is rewarding as it produces the layered effects I want.

One stitch, four ways

I use straight stitches in seeding, running stitch and cross stitches, applying the stitches as freely as I wish. I favour straight stitch not only for its ease of application, but also because it can be a very contemporary stitch, and its simplicity works well with pieces I have made from quite complex and bold fabrics and papers.

In short, straight stitch is the only stitch I need. To vary its appearance, I experiment with the length and density of the stitches.

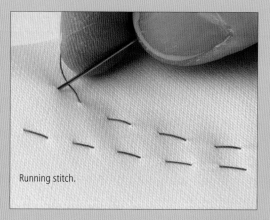
Running stitch.

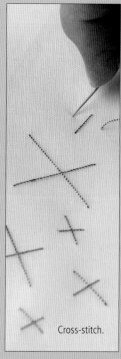
Cross-stitch.

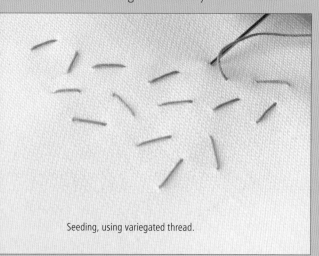
Seeding, using variegated thread.

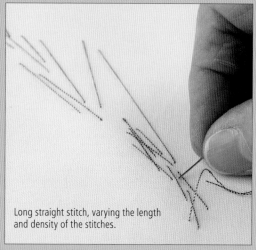
Long straight stitch, varying the length and density of the stitches.

Opposite
Hand-stitched sampler
By using a mix of simple straight stitches you can introduce line, texture, detail, colour and pattern into your work, as this sampler shows.

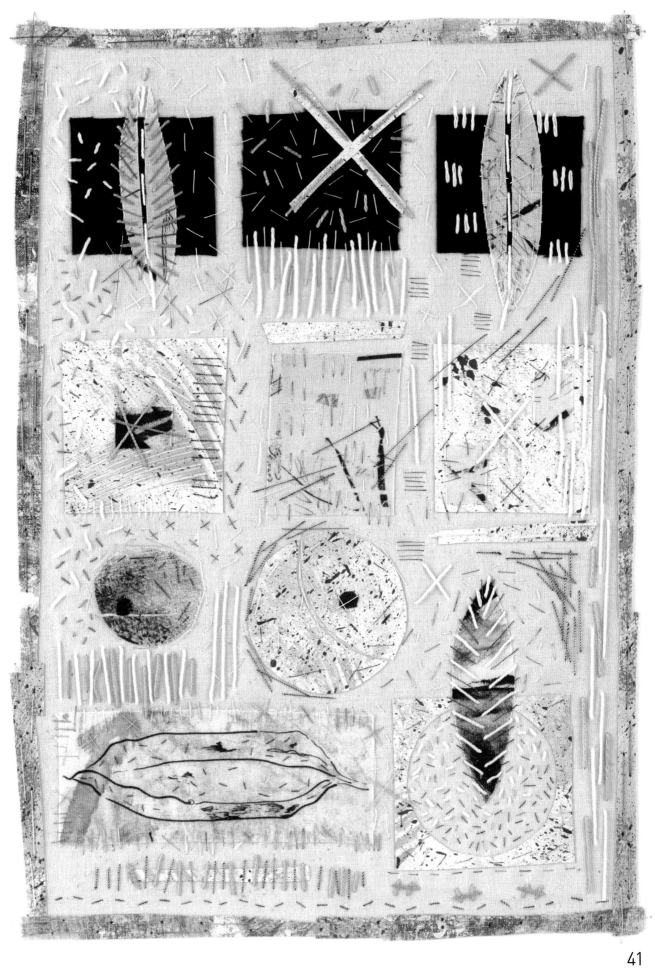

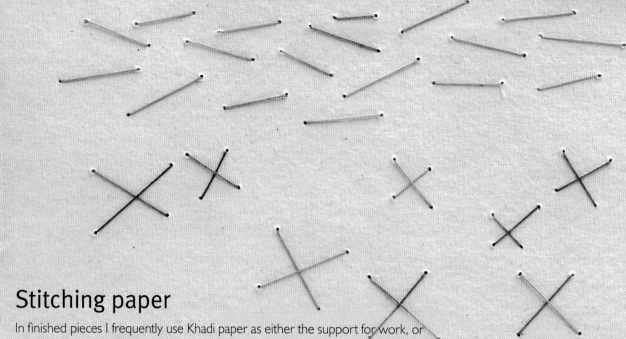

Stitching paper

In finished pieces I frequently use Khadi paper as either the support for work, or as the background of the piece. I use the 320gsm (140lb) weight for the pages of my artists' books (see pages 82–83) and I have often constructed pieces of work on the Khadi paper, using fabrics, other papers and mixed media on it, with machine-stitch and hand-stitch to complete the work.

I find that my machine is happy to stitch through 320gsm (140lb) Khadi paper, but my hand less so! I generally use a sharp bradawl and a piece of foam board to make the holes for stitches and beads. The bradawl can make rather large holes, so care is needed. I do find however that Khadi paper is very forgiving and a gentle rub with your fingernail or a small tool will fill in too large a hole after stitching.

I always use separate scissors for cutting paper. Khadi paper in particular requires good sharp scissors. To keep a deckle edge (a rough edge), the paper can be folded and ripped; for a very neat, accurate edge, the paper should be cut with a rotary cutter.

Opposite
Ginkgo
28 x 41cm (11 x 16in)
Fabric and paper appliqué on digitally printed Khadi paper, with machine- and hand-stitch, and added beads.

I used a sharp bradawl to make the holes for the hand-stitch and beads on this piece.

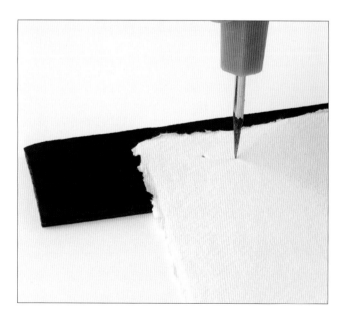

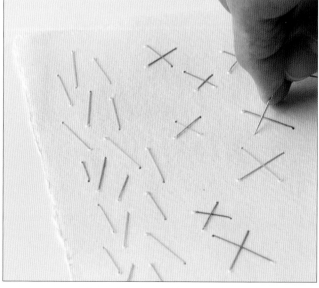

1 Use a sharp bradawl to make holes in Khadi paper. Keep a sheet of foam board underneath the Khadi paper to protect your work surface.

2 Hand-stitch the Khadi paper through the holes made with the bradawl.

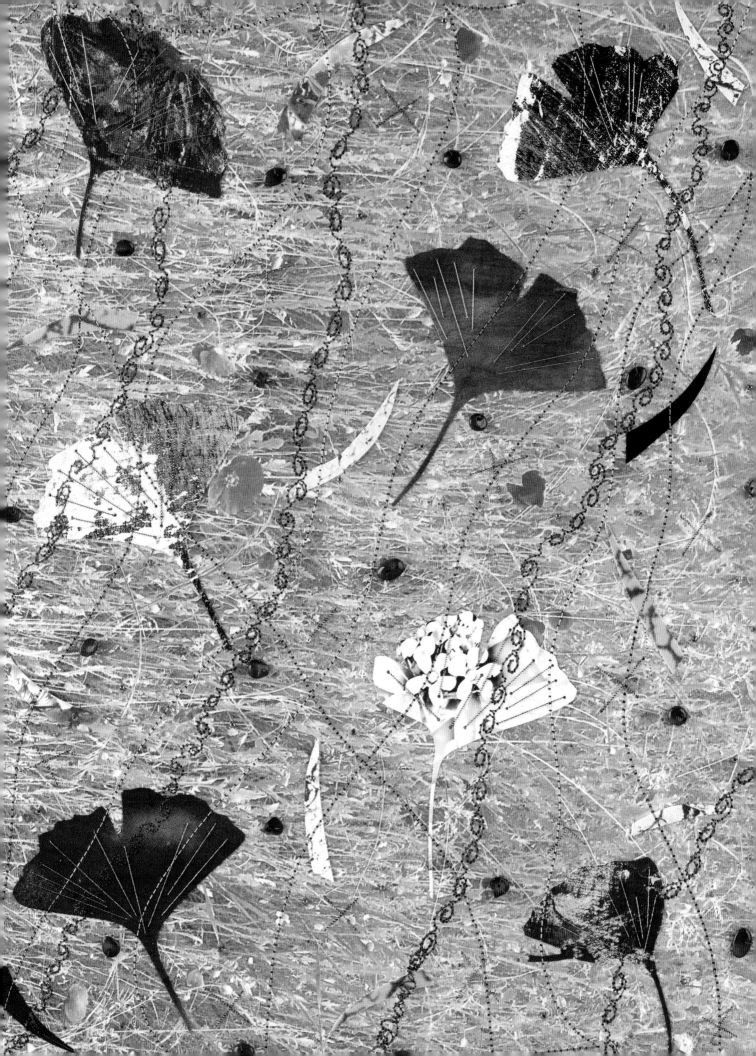

Embellishing your work

Adding embellishment has been part of my practice since I started to make stitched textiles, and has never been a last-minute decision; the pieces are conceived with this final layer in mind.

My favourite embellishments are beads, usually gemstone chip beads and smaller glass beads. I have made porcelain beads, too. There are so many wonderful ceramic and glass beads available that buying some simply because you like them can be a real creative act, as they can inspire new work or a different direction in your use of colour, for instance.

I always attach beads onto a piece using hand-stitch. With other embellishments, such as small pebbles, I glue the object in place first, then wrap thread over the object to secure it.

Tip

There is no need to add embellishments at all to your work if you think it is complete without them: consider first the look, and then the purpose, of the piece before you decide to add any embellishment.

Below

Embellished sampler

There are many ways of using the infinite variety of beads available, and in this sample I have stitched a range of beads over appliquéd fabric elements.

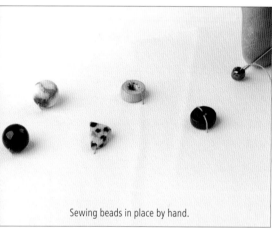

Sewing beads in place by hand.

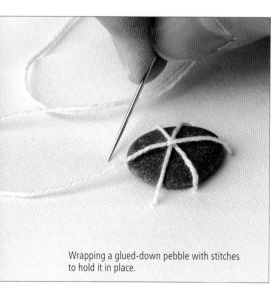

Wrapping a glued-down pebble with stitches to hold it in place.

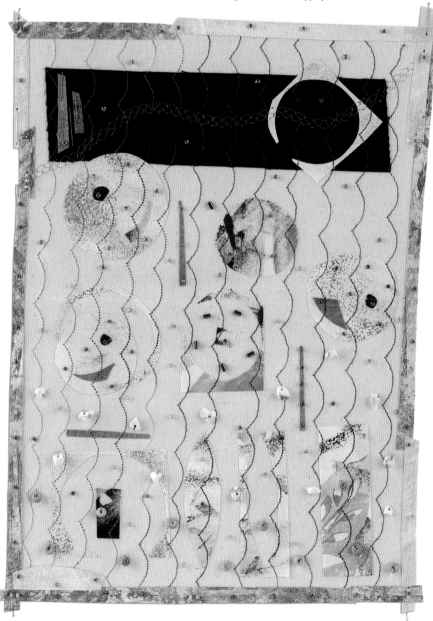

44

The three pieces on this page are from a series of work entitled *Gold*; they are made from recycled and found materials and mixed media. I painted and printed a mix of fabrics and papers, and added a range of embellishments, including metal from tomato paste tubes, driftwood, ceramic pieces, leaves, laminated Honesty seed heads (right, and below) and pebbles. They are machine- and hand-stitched, and mounted onto Khadi paper.

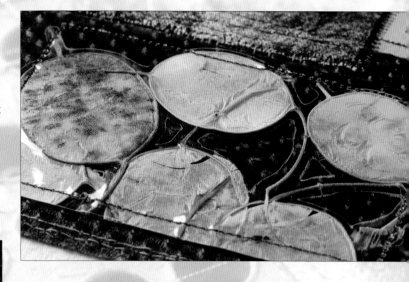

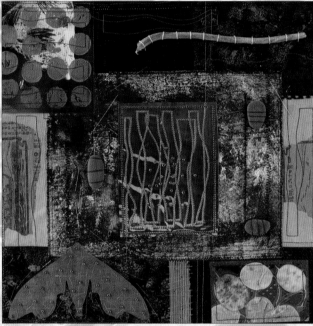

Gold (a series)
30 x 30cm (12 x 12in) each

The piece below, right, uses a found component of a travel game – covered in gold acrylic paint – as its centrepiece.

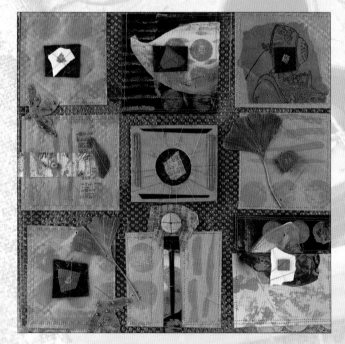

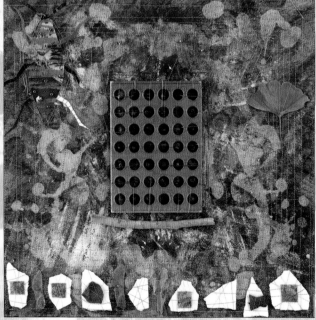

45

Painting on fabric

I started to colour my fabrics and papers with acrylic paints and a variety of inks over twenty years ago, and the techniques that follow are still my favourites. They are easy, adaptable and the materials are simple to use and accessible. When dry, the paints, which are pigments suspended in an acrylic polymer emulsion, will be fixed and water-resistant.

Producing a personal palette of materials for your own work in this way, and using this in combination with commercial fabrics and papers will make your work individual and entirely yours. I will be describing here how I use the various materials, but you may choose to use them differently. There is always room for experimentation and for developing your own way of working.

When I am painting and printing fabric I generally use medium-weight calico and white cotton; white cotton is best if you want your colours to be vivid. I also recycle printed fabrics, usually cottons. The ghost of the original design showing through a layer or two of paint can make a very interesting piece of fabric.

I also paint and print on black cotton, usually with white acrylic paint for dramatic effect. I don't wash new fabrics before painting and printing – with a small amount of persuasion they will accept paint and inks. It is a good idea though to first iron out creases, as the paint will fix them, and they may be impossible to remove by ironing.

Acrylic paint on calico

You can use a thin wash of acrylic paint to produce a watercolour effect, or layer it on more thickly for a sculpted, impasto look. I generally go for something in between, and although my sewing machine sews through them happily, I must say that thickly painted areas are not always easy to hand-stitch. If this is the effect you want, use less hand-stitch, or make the holes for the needle first.

I use large household paintbrushes, sponges, rollers and occasionally an old toothbrush as my chief painting tools.

Acrylic paint disposal

It's important to minimize the environmental impact of waste acrylic paint to keep as much plastic as possible out of our water systems and oceans. I rarely have acrylic paint left over, as I paint pieces of fabric until the paint has been used up entirely. I then paint until my brushes are as clean of paint as possible.

If you have acrylic paint left over at the end of a project, try putting it in an airtight container to be kept for future use, as it will sometimes remain useable.

To clean brushes, print blocks and palettes of acrylic paints, wipe them thoroughly with paper or rags, and dispose of them in the solid waste. Use as little water as possible to wash the brushes, and tip the water you do use onto your used rags or paper and dispose of them.

Tip

One thing to remember when producing your own materials in this way is that while you may not be happy with a particular result, you may be able to add more paint and print to change it. Keep everything you make; put all your pieces away for a week or two, then return to them with fresh eyes. The most unlikely experiments can turn out to be the most useful – you can always cut up a piece of painted fabric, and use it in collage; it might turn out to be inspirational after all.

1 Lay down a brushed area of paint first, then continue to work onto that. I often start with white acrylic as a base coat. The cream colour of the calico shows through, too, which adds depth. Apply titanium-white paint using a 50mm household paintbrush.

2 Lay a second layer of narrower brushstrokes in a different colour; this builds up the colour and the visual texture on the fabric. Here, the paint – a mix of cerulean blue and titanium white – is applied with a 25mm household brush.

Tip

Although acrylic paint can be washed off your hands, it can take some scrubbing so you may wish to protect your hands with latex gloves. Acrylic inks can stain your skin so take care to wear gloves when working with the inks.

3 A third layer – perhaps in a complementary or analogous colour – can be applied in even smaller strokes with an artists' flat paintbrush.

The end result.

Varying your painting tools

In addition to the traditional paintbrushes I use a variety of different tools to apply more texture and interest to my fabric surfaces.

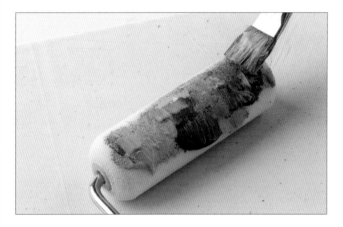 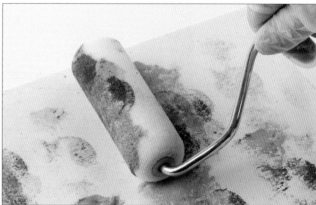

1 Load a sponge roller with a mix of acrylic paints from your palette and roll the colour onto your fabric.

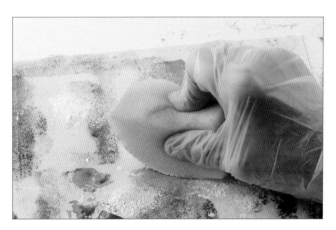

2 Press the paint directly onto the fabric using a piece of sponge or foam.

3 Load an old toothbrush with acrylic paint and flick the head of the brush to produce a splatter effect to add an extra layer of visual texture to the surface. Here, I have used metallic copper acrylic paint.

The end result.

Painting on cotton

Watery acrylics brushed onto white cotton are very effective and result in a watercolour effect.

1 Wet your fabric first, before applying any paint. Begin by painting gentle lines in your first colour choice (here, cerulean acrylic paint) using a splayed brush.

2 Sweep the second layer – here, lime green – over the top and around the areas of blue.

Using acrylic inks

Acrylic inks are also excellent for colouring fabrics and papers; they are quite powerful and often need to be watered down, so experiment a little first. Pearlescent and metallic inks are easy to apply and can add interesting layers to fabric and paper, and brighten dull areas.

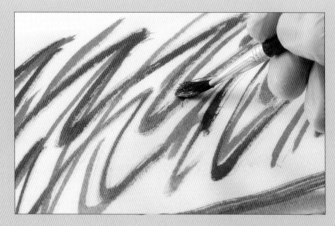

Tip
Fabrics painted with acrylic inks are best left to dry overnight before you use them in your collage or appliqué work.

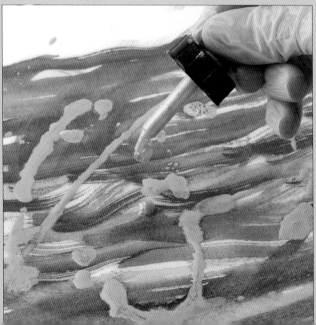

Silk painting

Using Dye-na-Flow fabric paints on medium-weight silk Habotai, I paint with loose, expressive brushstrokes to create a translucent, coloured fabric. I also use clear, water-soluble gutta as a resist to add pattern. I then cut up the pieces of painted silk to use as additional layers to my work. These silk elements add subtle depth and colour to a piece.

Materials

Medium weight silk Habotai

Baking parchment for use when ironing

Water-soluble gutta (I use clear gutta)

Dye-na-Flow fabric paints (here, I have used hot fuchsia, azure blue, golden yellow, turquoise, chartreuse and brilliant red)

Fusible web

Equipment

Frame (mine is a homemade wooden frame – see page 21)

Thumb tacks

Fabric scissors

Artists' round paintbrush (I have used a size 20 round brush)

Iron and heat-resistant surface

Note
This technique takes time to complete as the gutta, and the paints, must be left to dry – ideally overnight.

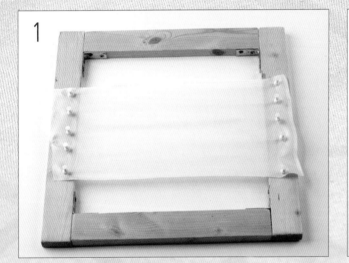

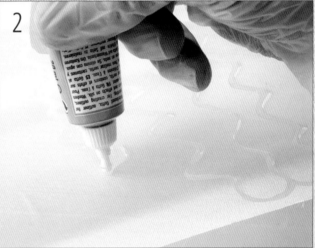

1 Stretch the silk over the frame and pin into place with the thumb tacks, keeping them about 3cm (1in) apart. Ensure the silk is taut.

2 Apply the gutta to the silk in assorted patterns – squiggles, squares, circles, dots and lines. Allow to dry (preferably overnight).

3 Once the gutta is dry, apply the fabric paint in loose strokes over the resist with a paintbrush. Use a variety of colours and feel free to mix and apply them however you feel.

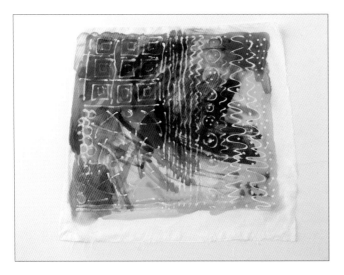

4 Once you have painted the gutta patterning, leave the fabric to dry.

5 Iron the fabric to fix the paints, using a sheet of parchment paper between the iron and your fabric. Then handwash the fabric thoroughly to remove the gutta. Dry the fabric, and iron some fusible web to the back of the silk – I find this helps when cutting out shapes as it makes the silk firmer and easier to handle.

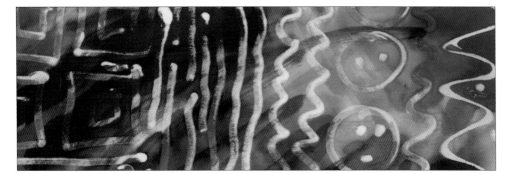

Your fabric is now ready to be used.

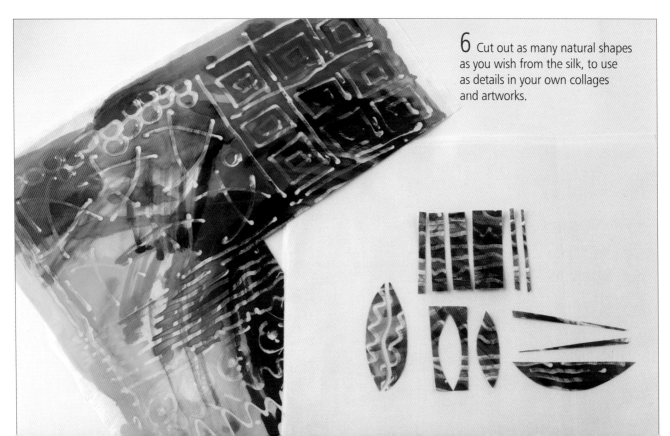

6 Cut out as many natural shapes as you wish from the silk, to use as details in your own collages and artworks.

Printing on fabric

Using a variety of fresh leaves to print from – either as a stencil or a stamp – has been one of my most-used techniques; cutting a large leaf into shapes, such as squares, is something I find particularly effective when patterning fabrics.

Materials

Assorted fresh leaves

Acrylic paints (I have used leaf green, cerulean blue and naphthol crimson)

Black cotton and white cotton (plain fabrics show this technique more clearly)

Equipment

Sponge

Kitchen paper

Paintbrush (I have used a flat wash brush, size 6 – a brush with soft and flexible synthetic bristles is ideal, so the leaves are not damaged)

Using leaves as stencils

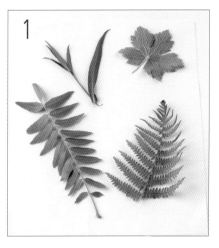

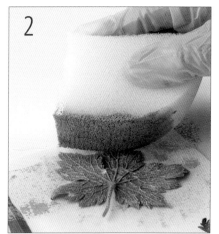

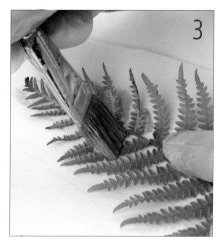

1 To use leaves as stencils, place one, or a selection, onto your fabric. Here, I have used white cotton.

2 Using a sponge or paintbrush, gently and sparingly cover the back of the leaves with a thin coating of undiluted acrylic paint. I have used leaf green and cerulean blue.

3 Remove the leaf carefully and you will have a subtle ghostly leaf shape. This is excellent for building up pattern and colour on the fabric. The veins on the back of the leaves are more pronounced, which will then make a better, finer print if you then use the leaf as a stamp.

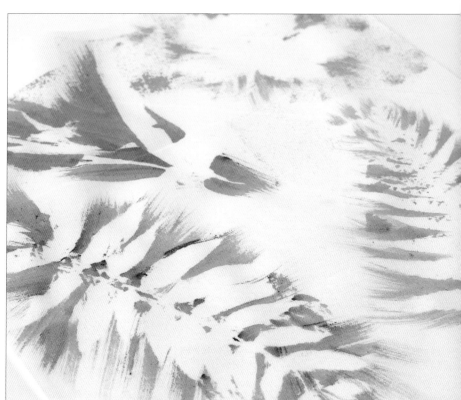

Stamping cut leaves

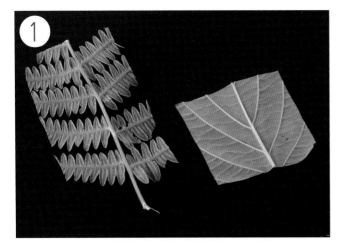

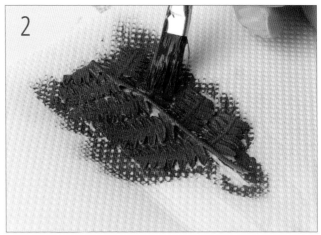

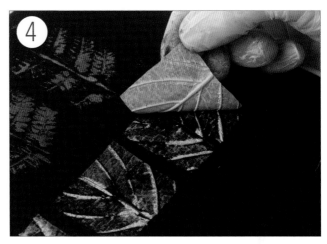

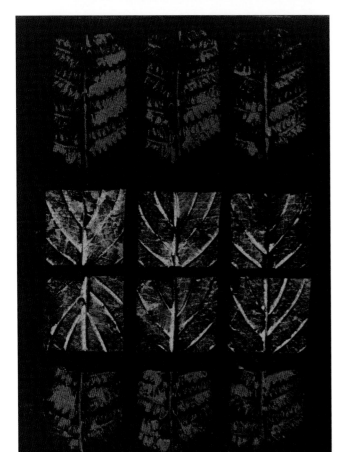

1 Cut a selection of fresh leaves into shapes. Neat geometric shapes work well as they are in direct contrast to the leaves' natural shapes.

2 Lay your leaves on a sheet of kitchen paper and paint over the back of them with a thin coating of undiluted acrylic paint. Here, I have used leaf green and naphthol crimson.

3 If the leaf is too heavily painted, blot a little of the paint off with some kitchen paper. If the leaf is more complex or delicate, like this fern, put it carefully onto the fabric and lay a clean piece of kitchen paper on top before you press it down, to prevent the leaf from moving about and losing definition. Alternatively, if the specimen is sturdy, you can press the leaf itself onto the fabric, as I have with the green square leaf. Here, I have printed brightly coloured acrylics onto a black cotton surface for drama and interest.

4 Peel back your leaf or your kitchen paper to reveal your geometric leaf stamp print.

Monoprinting

Monoprints are fascinating and easy to make on both fabrics and papers. Monoprint means producing one print from one plate at a time; no multiple prints are produced. A monoprint can introduce remarkable effects and visual surface textures to your work, and just a couple of good monoprints can inspire and inform some exciting new pieces. I frequently produce monoprints that I dont want to cut up, and will find a way to base whole pieces of work around them.

To produce a monoprint you need a flat, waterproof base, such as a piece of acrylic, a laminated sheet of white paper, or a gel printing plate – the plate used in this example is 30.5 x 35.5cm (12 x 14in).

Leaves, other plant materials such as stems, and cut-paper stencils are just some of my mark-making materials when producing monoprints. There are also many designs of acetate stencil available, and these can be very useful if you prefer not to make your own stencils. Print blocks can also be used for impressing onto the painted surface of the plate before taking a print, and marks made with a pointed tool such as the end of a paintbrush also add detail.

Materials

Gel printing plate or other plastic or acrylic surface, 30.5 x 35.5cm (12 x 14in)

Acrylic paints (I have used lime green, white, Turner's yellow and indigo blue)

Sheet of calico slightly larger than the gel plate

Household and artists' paintbrushes

Brayers

Leaves and grasses

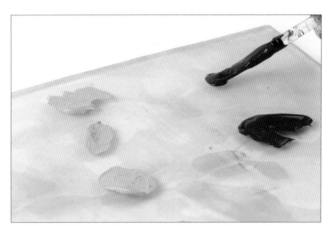

1 Use a household paintbrush to dab the acrylic paint on to the gel plate, keeping your colour choices separate. For this example I have used lime green, Turner's yellow and navy blue.

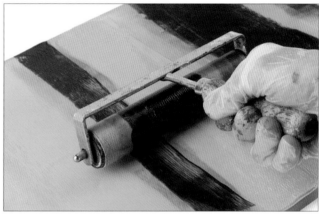

2 Use a brayer or roller to roll the colour over the plate. Make sure that you cover the whole area of the gel plate.

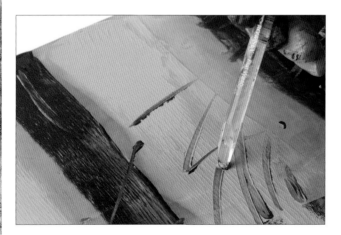

3 Use the handle of a paintbrush to scribble in some marks, moving the paint from one area to another.

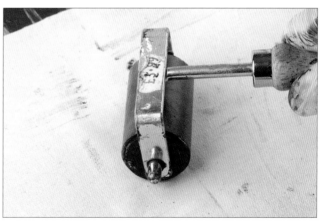

4 Lay your sheet of calico over the painted gel plate. Roll over the back of the fabric firmly with a clean brayer to transfer the paint from the gel plate to the fabric.

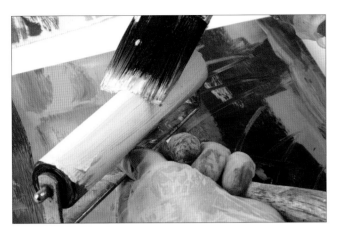

5 Use a paintbrush to apply more paint directly onto a brayer.

Your monoprint in progress.

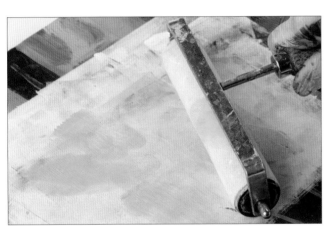

6 Apply a second layer of paint to the gel plate. I have also added, with a brush, a few dabs of lime green.

Tip

If you feel your monoprint needs further development, you can print over it until you achieve an effect you are happy with. This process can make the print quite visually dense; I find I overprint at least three times, using different colours at each stage to achieve the effect I want.

7 Lay your collection of leaves and grasses on top of the paint layer.

 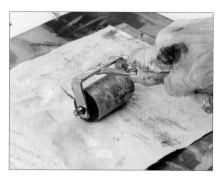

8 Place the calico down on top of the gel plate and roll the brayer over the fabric surface to allow the calico to pick up the print of the paint and the greenery, then lift to reveal. The leaves and stems act as stencils, producing a delicate effect. The painted leaves can then be used to add prints to the fabric surface if you wish.

9 Dab white acrylic paint onto a paintbrush and make marks at random over the painted area to add texture and interest.

10 Finally, lay the calico on top of the gel plate again and print the last layers of paint onto the fabric using the brayer. You can use the painted leaves and stems to add more prints to the fabric surface if you wish, or continue to add paint and print until you are happy with the result.

The monoprinted fabric

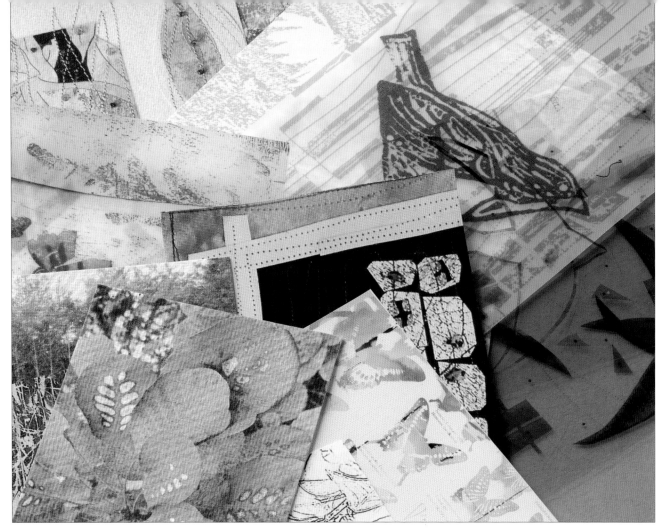

A selection of my digitally printed papers on Khadi paper, tracing paper, cartridge paper and acetate.

Digital printing

In addition to monoprints or block prints, I enjoy making digital prints as part of my work practice. Digitally printed materials introduce another dimension of detail and focus into a piece, adding fascinating depth and interest. I print onto a range of papers which I use in my sketchbooks, on design sheets, in stitched, mixed-media work such as my artists' books (see pages 82–83) and the work entitled *Magnolias*, shown on page 117. I also print digitally onto fabrics. I print from my own photographs, and from images of my own work, both drawings and stitched pieces.

Occasionally I use digital manipulation software to alter and layer images on my computer; I print them using a large inkjet printer – I have found inkjet printing onto calico and white cotton successful. I iron the fabric onto waxed paper, to stiffen it, and usually cut it into 29.7 x 21cm (11¾ x 8¼in) or 29.7 x 42cm (11¾ x 16½in)-sized pieces, before feeding it through the printer. I keep a border of fabric around my images to account for any possible smudging from the ink.

Alternatively, you can purchase fabrics that are readily suitable for inkjet printing, and you can choose from washable or non-washable fabrics – the former are ideal if you are working on a piece of artwork that will need to be laundered, such as a quilt or cushion cover.

Developing a design

My work is constructed using appliquéd elements. The elements could be fabric, paper and other mixed media, and could be supported on a paper or fabric background, which has been painted or printed using the techniques I have demonstrated on the previous pages. The construction of a piece is a layered, stage-by-stage approach, starting with the appliqué stage, which involves laying down the elements of the piece onto a background or backgrounds.

When I lay down my work, I am already thinking ahead about stitch and embellishments. I don't plan every stitch, but I am always aware that a piece of work is a series of layers that starts with the appliqué and builds through the application of stitch, be it machine-stitch, hand-stitch, or both. Added to this is the application of embellishments, either beads or other media, to add the final punctuation to the work.

The following pages show how I developed a design from sketch to stitched-textile work to create *Winter Garden*, a variation of which can also be seen on pages 92–93.

This project follows on from the drawings and sketches shown on pages 24–25.

Winter Garden

1 I create pattern pieces by tracing a selection of elements from the original drawings (see pages 24–25). Photocopying is also useful for replicating elements.

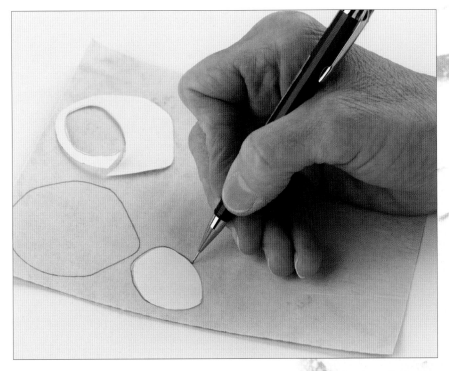

2 After choosing the fabrics I want to use in the piece, a small number of painted and printed fabrics in complementary wintry colours of cream, grey, black and red, I experiment with different choices of fabrics for backgrounds and elements simply by laying the fabrics side by side and on top of each other. All the fabrics have fusible web on the back. Here, I trace the shapes, or draw around the cut-out elements onto the paper backing of the fusible web. You can cut out the elements from the tracing paper or trace them onto sturdier card if you wish. The latter is quite useful if you are going to use the pattern shapes many times.

3 I place the individual shapes onto a plain calico background. Backgrounds do not have to be plain, but in this case it suits the character of the piece.

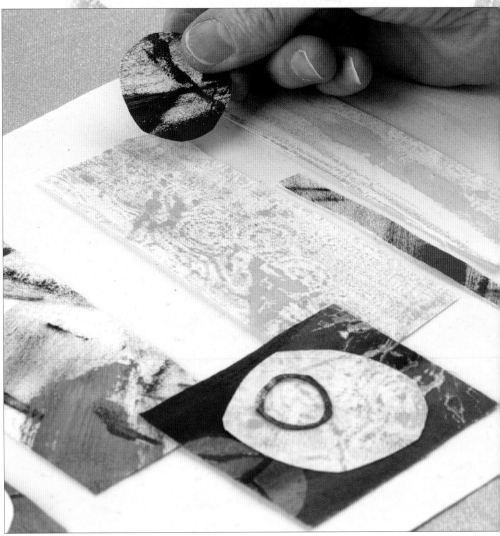

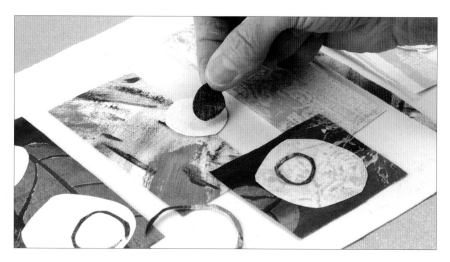

4 I spend a great deal of time trimming and refining the elements, and moving them around until I am completely happy with my arrangement. I use the trimmings of the fabric from the berries to produce additional natural shapes.

5 I iron the pieces in place, ready to be stitched. I then back the piece by ironing it onto another piece of sturdy fabric, to ensure that neither machine- nor hand-stitch will cause it to pucker.

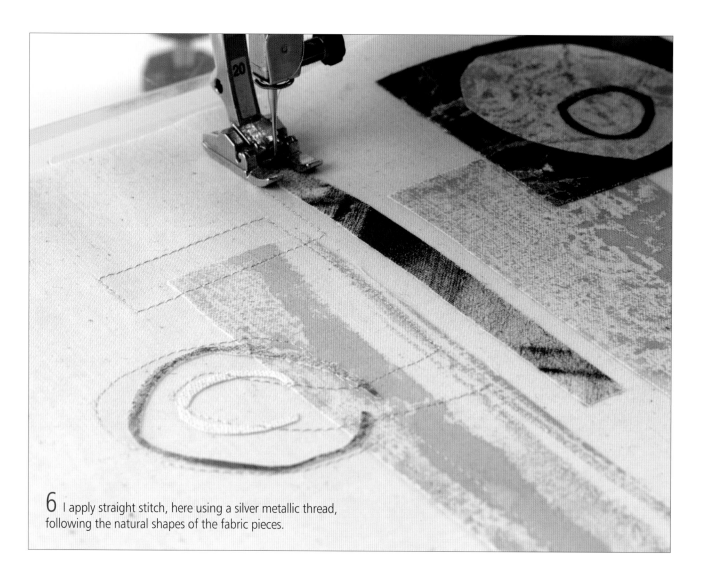

6 I apply straight stitch, here using a silver metallic thread, following the natural shapes of the fabric pieces.

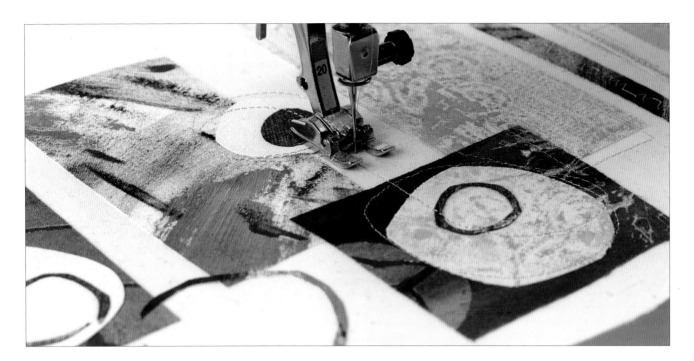

7 I machine-stitch with the feed dogs of my machine in the up position, as I feel this gives me an accurate and neat line. I move the calico around beneath the needle, stitching in circular motions, wavy and straight lines, going over the edges of the fabric in some places and simply stitching over the calico background in others. The introduction of these drawn lines of machine embroidery are a very important part of the design and character of the piece.

8 Switching to a different colour thread – here, red cotton – and still using straight stitch, I follow some of the stitches I have made with the silver thread, then mirror some of the natural shapes of the fabric pieces.

9 Changing to a zigzag stitch, I stitch over some of the straight fabric elements to add more detail.

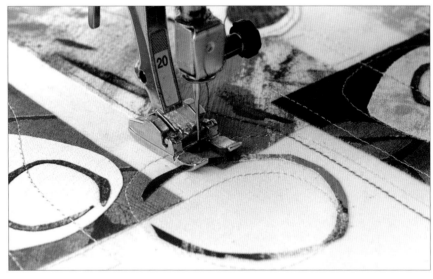

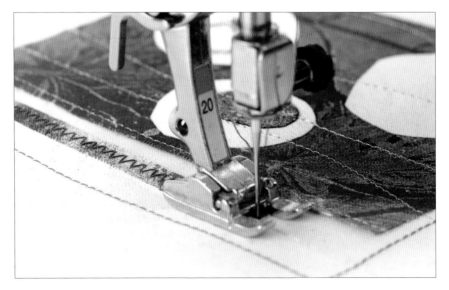

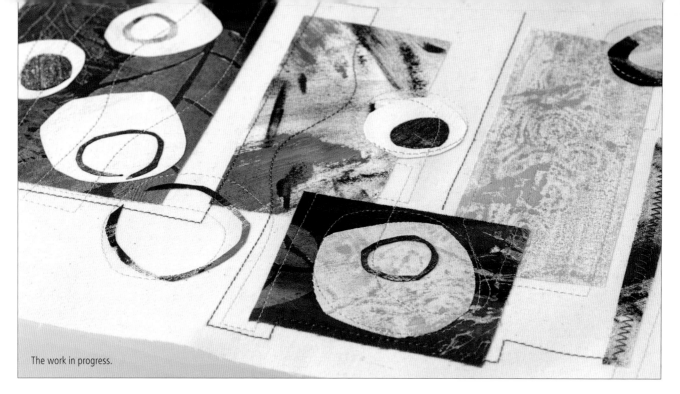

The work in progress.

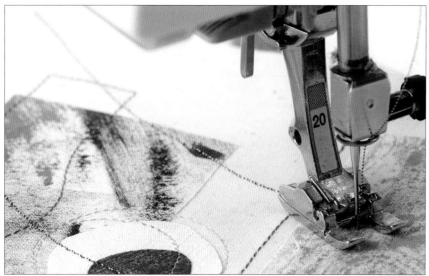

10 Changing to an antiqued silver metallic thread, and using straight stitch again, I continue to add to the patterns and natural shapes I have already made with the previous stitches, for a multi-layered effect.

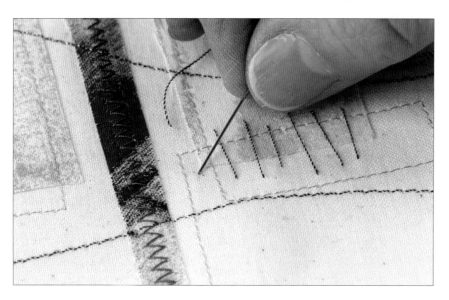

11 Switching to hand-stitching I use a metallic black and silver mix thread to run a series of long stitches along the bottom edges of some of the fabric shapes. I move and rotate the fabric at intervals to make it easier to reach certain areas of the work. I apply floating cross-stitches across the work in silver thread to add to the illusion of movement in the piece.

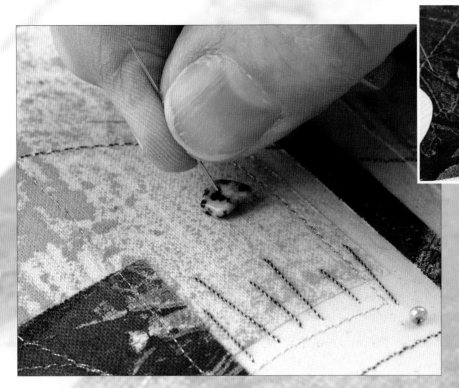

12 Finally, I begin to stitch on some embellishments, beginning with patterned gemstone chip beads and tiny pearls.

13 A careful selection of seed beads is sewn on as a final flourish: reds, silvers and blacks complement the colour scheme perfectly.

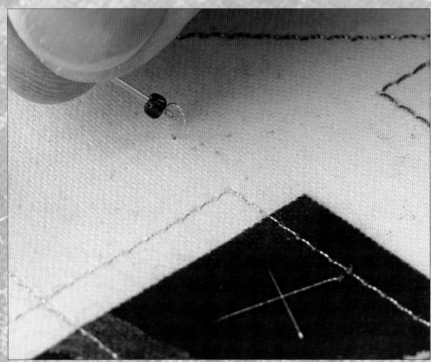

The finished piece can be seen overleaf.

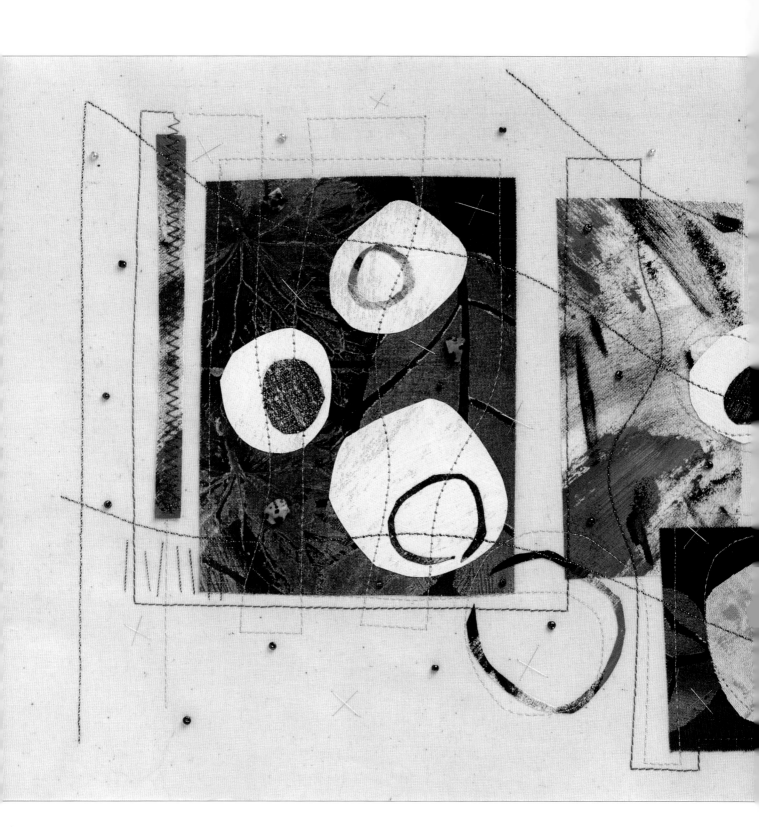

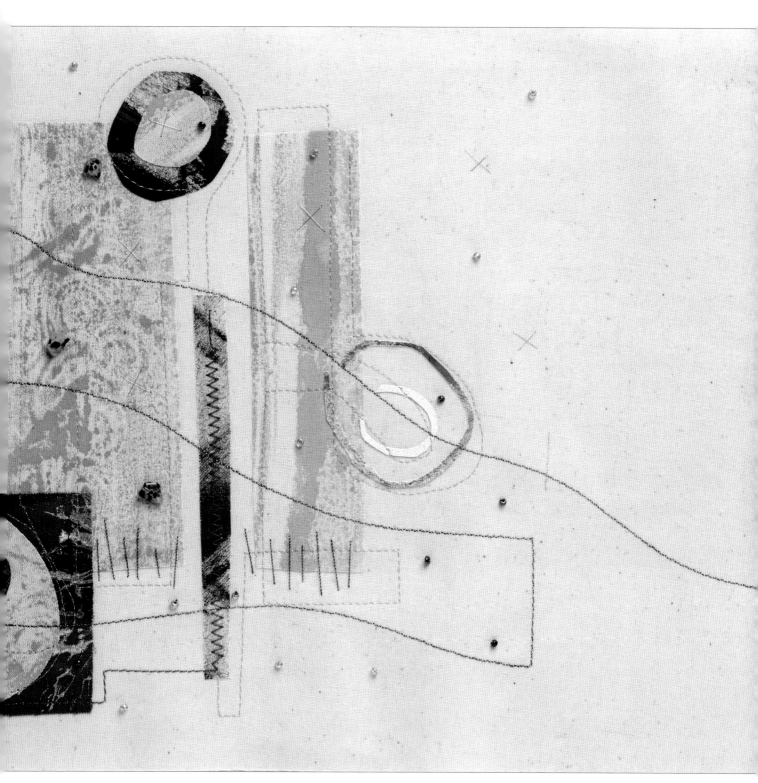

Winter Garden
51.5 x 22cm (20¼ x 8¾in)

Themes

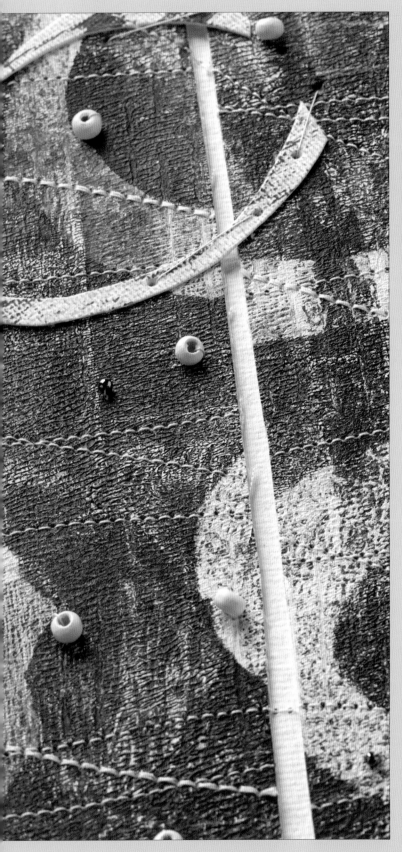

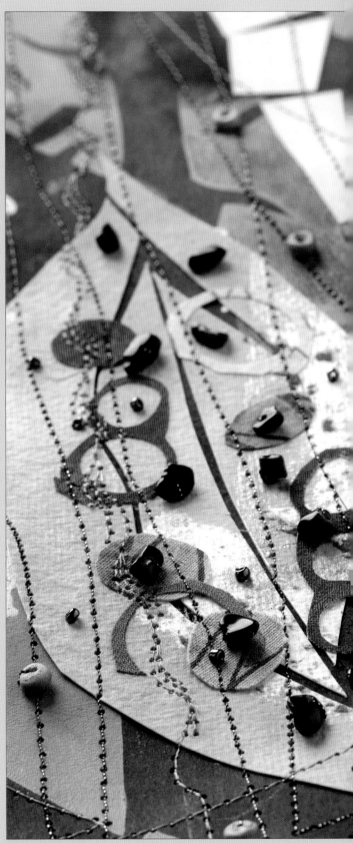

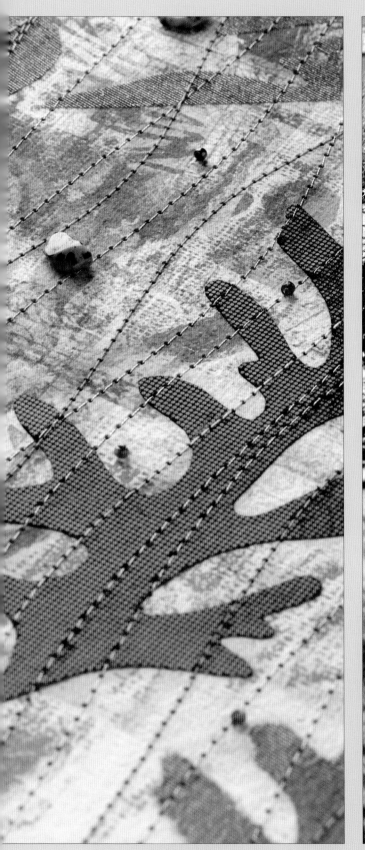
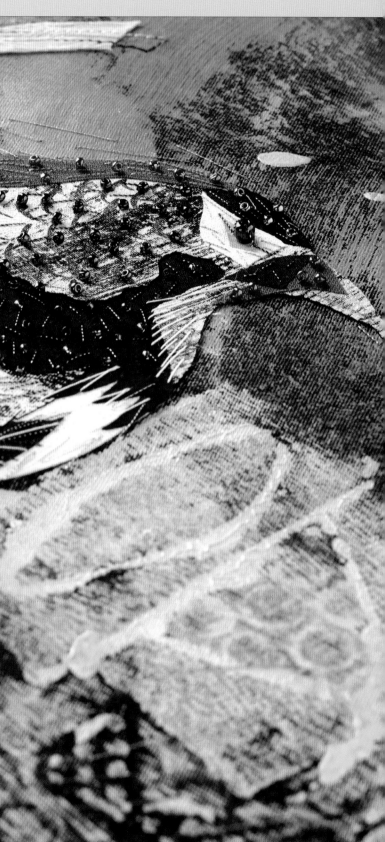

Ocean

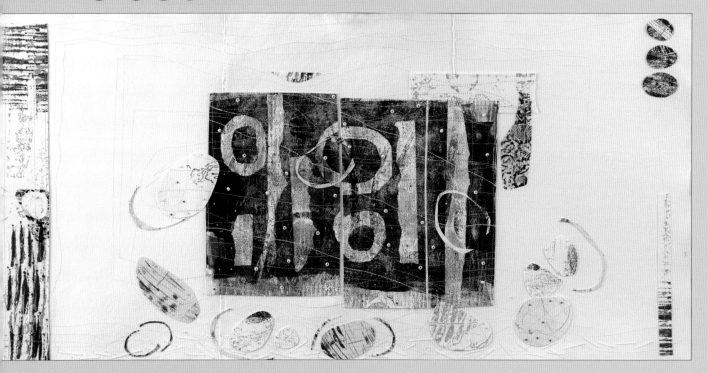

Nature provides astonishing amounts of visual stimulus for creative work. In these chapters I show finished pieces of my work, describing how I chose my resources, my design development, interpretation, building the piece and finishing.

Walk
88 x 43cm (34¾ x 16¾in)
A detail of this work is shown below.

Taking inspiration

I was a ceramist for twenty years, and inspiration from the ocean and beach were the mainstay of my work for many of those years. I have always lived inland and put my obsession with the sea down to the fact that I am not near it as often as I would like to be. When I started to make stitched textiles I continued to use the sea and coast as subjects in my work.

If you are looking for a subject that will provide endless visual stimulus leading to inspiration for your work, the ocean and its environs will provide shape, colour, texture, sweeping spaces and glorious detail.

The piece shown on this page, *Walk*, is based upon holiday walks on the beach. I have many photographs to which I refer when starting a new beach or sea piece, and this work was informed by images of pebbles, light on the sea and in the sky, and the linear configurations of the sand. A couple of sketches in which those elements were gathered together was followed by a trawl through my fabrics and printed paper collection. A number of mixed papers I had printed previously, both by hand and digitally, seemed ideal for the piece, so the picture is made almost entirely of printed papers: there is also one piece of digitally printed acetate in the work.

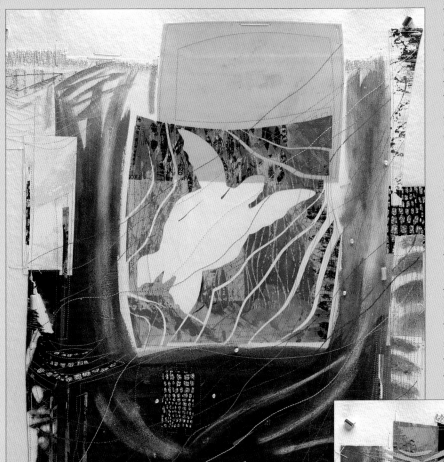

These two pieces, *Beach Thoughts: Beneath the Waves*, explore the environment of the deep oceans and the coast, and feature one of my favourite animals, the green turtle. The repeated image of the turtle serves to relate the pieces, as does the colour scheme.

These fabric and paper pieces were made from painted and printed calico and Khadi paper, digitally printed Khadi paper and acetate, and metallic fabrics.

I finished the pieces with machine-stitch in white cotton and metallic threads, and added some gemstone beads and small pearls. They were then mounted onto very thick Khadi paper; to integrate the works and their Khadi paper backgrounds I used some large simple stitches in thicker white cotton, using a bradawl to make the holes.

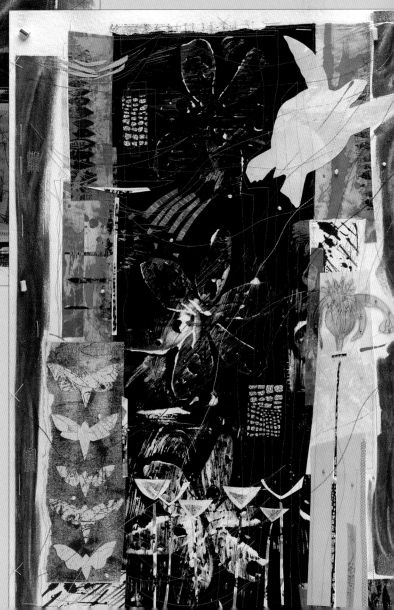

Beach Thoughts: Beneath the Waves
56 x 76cm (22 x 30in) each piece

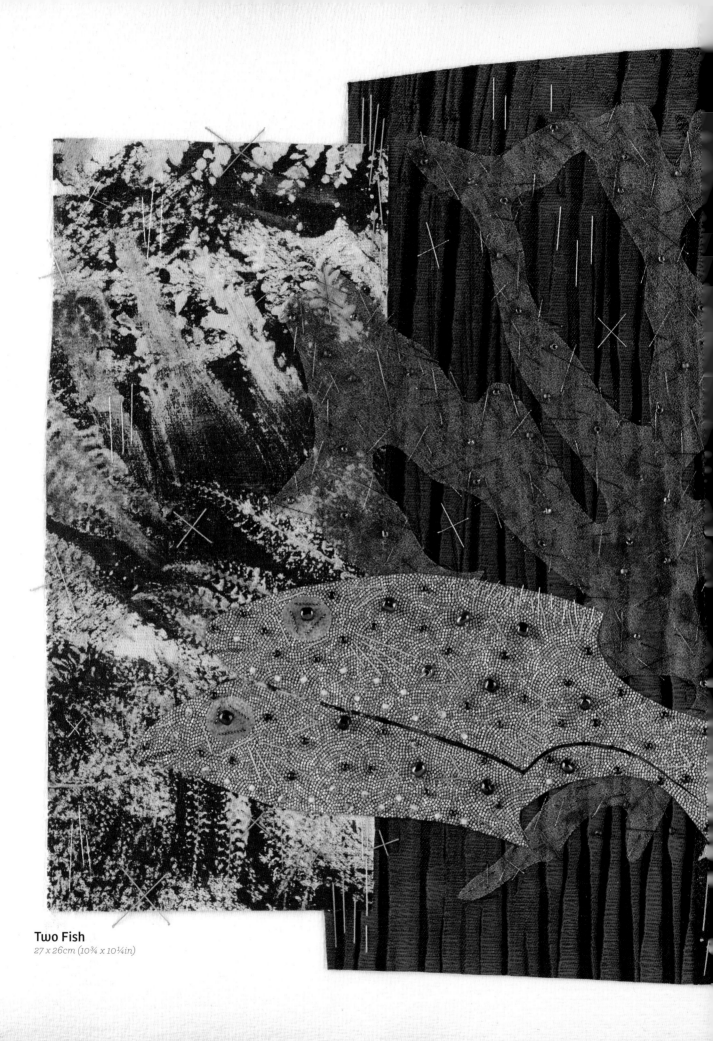

Two Fish
27 x 26cm (10¾ x 10¼in)

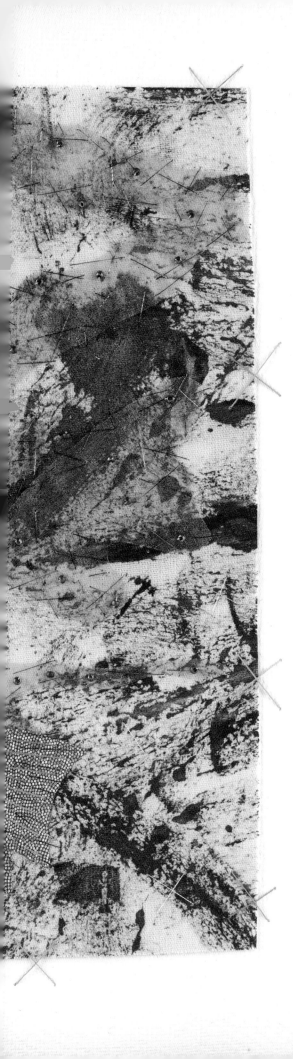

A pair of uncomplicated fish swim against a more complex sea fan in this piece, made from painted and printed fabrics, metallic commercial fabric and silk organza.

The background fabrics were from my collection, and I had only small pieces left, so I used them as they were, with a trim of the edges to neaten them. This created an interestingly shaped triptych on which to place the other elements. I like the fact that the materials seem to make the fish and the sea fan appear to move mysteriously in and out of the background, bringing a sense of the secret and hidden life of the ocean.

I hand-stitched this piece using variegated cotton and metallic threads, with added beads.

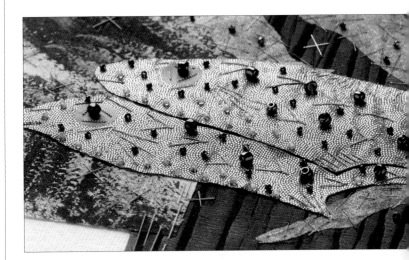

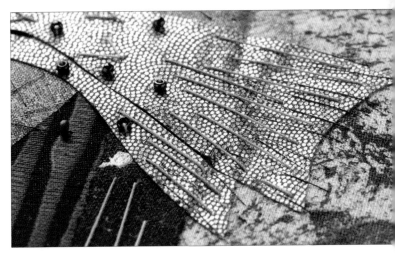

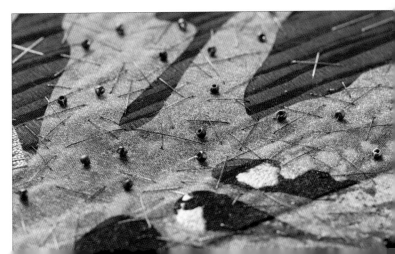

Sea Horses and Starfish

The patterns for this ocean-themed project can be adapted in a variety of ways. Here, I show how to make a stitched picture which would be suitable for mounting and framing, but you could use the patterns for other projects such as cushion covers and quilt blocks. You can also change the shape and size of the background and arrange the elements as you wish. The pattern pieces can also be enlarged; you could use a mix of smaller and larger elements in your piece of work.

Materials

Background fabric, 30 x 30cm (12 x 12in) backed with fusible web (I used black cotton, monoprinted – see pages 54–57)

Backing for the piece: black felt is ideal, at 30 x 30cm (12 x 12in)

One piece of calico, 30 x 30cm (12 x 12in), painted and printed, for the creatures. This should also be backed with fusible web

Machine threads and beads of your choosing, to match your colour scheme

Baking parchment for use when ironing

Templates (see page 124)

Equipment

Fabric scissors

Iron and surface for ironing

Sewing needles

Sewing machine

1 Peel the paper from the fusible web and iron your background fabric to the backing fabric (black felt). This will make the whole piece sturdier and more pleasant to handle when machine-stitching the work, as it prevents puckering and distortion.

Ironing background fabric to backing fabric
Use a protective layer of parchment between the iron and the fabric.

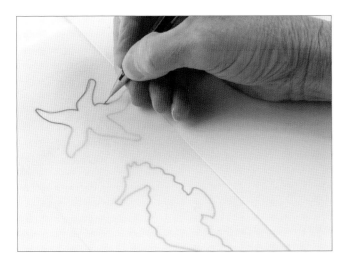

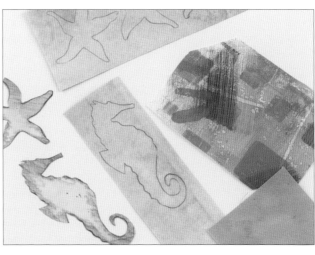

2 Trace the pattern shapes from page 124 to make as many sea horses and starfish as you want to include in the design. These can then be cut up to make into your pattern pieces.

3 Transfer the shapes onto small painted and printed pieces of calico backed with fusible web.

4 Cut the creatures out of the painted and printed calico.

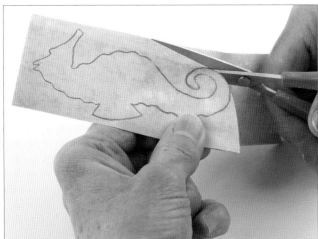

5 Arrange the creatures on the background. Cut out small contrasting triangles for the patterns on the sea horses and small circles for the centres of the starfish from the painted and printed calico. Place these onto the creatures and, when you are happy with the arrangement, iron the elements onto the background using parchment between the work and the iron.

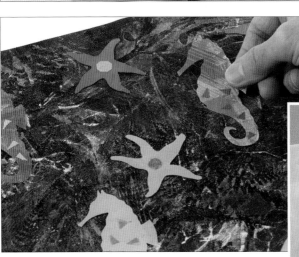

6 I used variegated cotton in colours sympathetic to the piece to begin the machine-stitching, stitching back and forth in wavy lines and stitching along the edges as I changed direction. Do not be afraid to stitch over the creatures, as the wavy lines serve to involve them fully within the scene and also add strength to the structure of the piece.

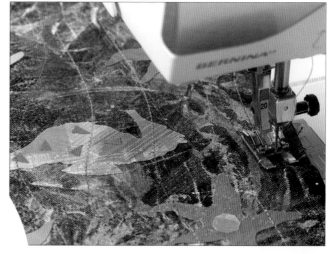

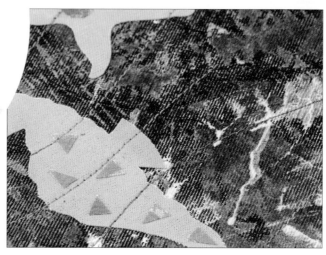

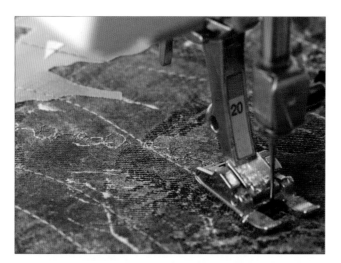

7 Switch to a decorative machine-stitch (I have chosen a stitch with a looped effect). Starting from the top-left corner, run the decorative stitches diagonally all the way across the piece. Repeat to add a second and third line of similar decorative stitches above and below the central diagonal line of stitches.

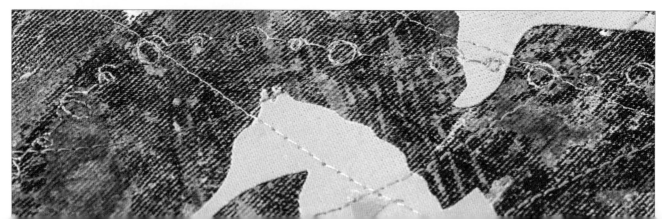

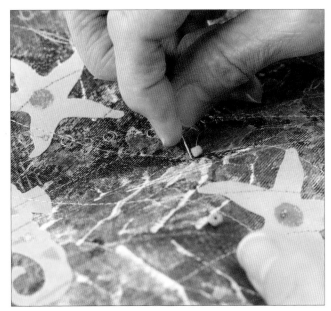

8 Select a variety of seed beads in different sizes and in complementary colours to embellish your piece. I have chosen pale orange and dark orange beads, with translucent blue seed beads for the sea horses' eyes. Thread the beads onto the piece on continuous lengths of metallic silver embroidery thread and tie off the thread at the back of the piece to complete.

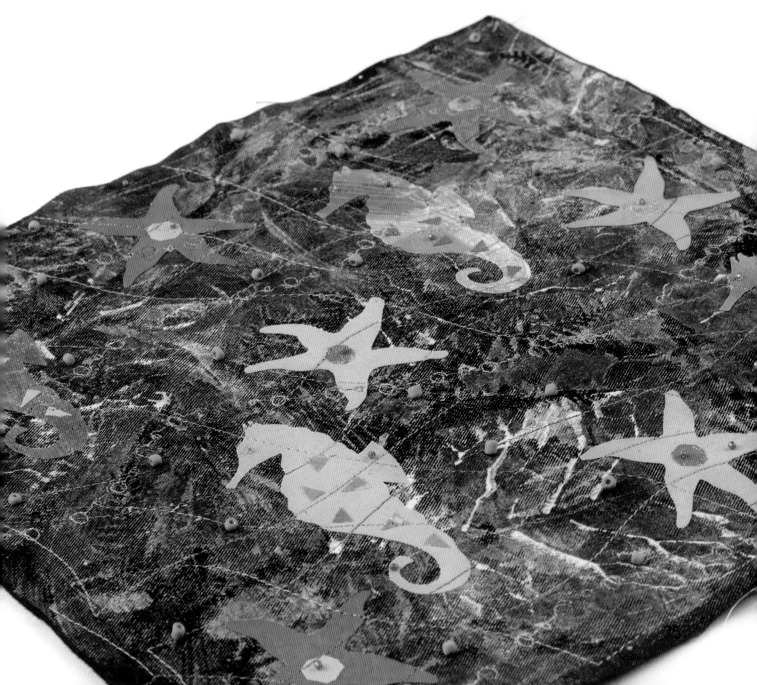

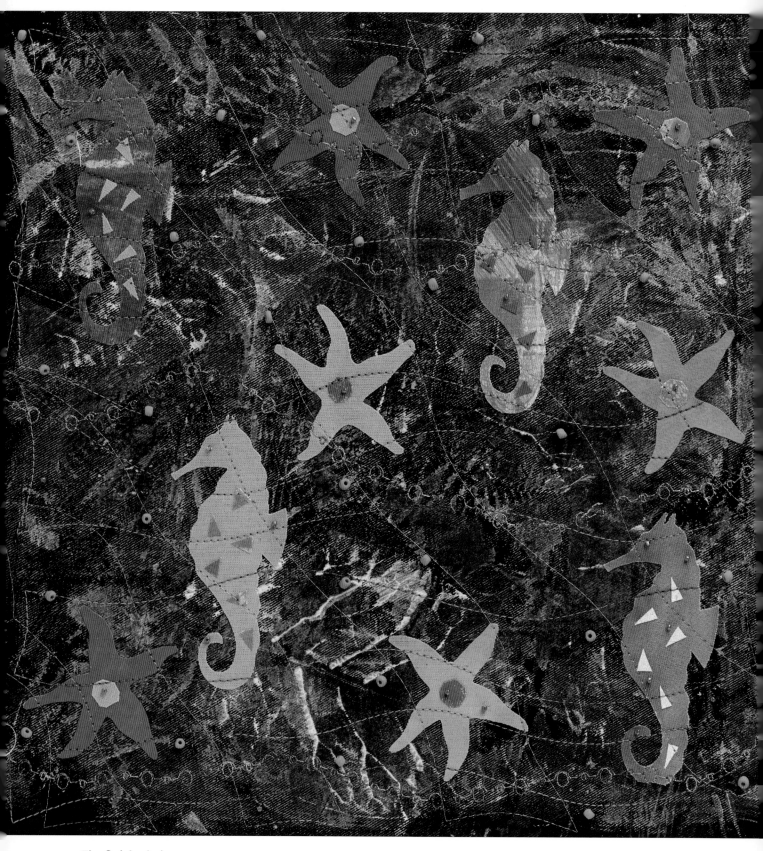

The finished piece

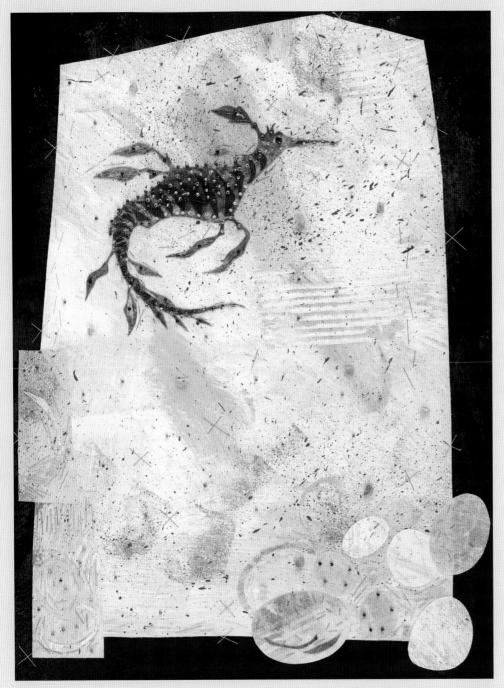

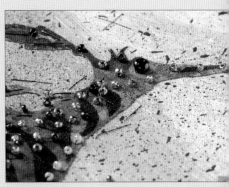

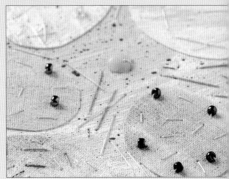

Leafy Sea Dragon
43 x 33cm (17 x13in)

In the piece above, *Leafy Sea Dragon*, I have concentrated on a smaller, more intimate underwater world. I wanted to evoke, in part, the glowing pages of an illuminated manuscript, its lustrous jewel colours and rich detail.

Sea dragons and sea horses offer great opportunity for embellishment, and sea dragons especially are found in considerably more elaborate forms with many more appendages than this little creature. However, I wanted to make the shape intricate without being too overwhelming, so I chose a simpler member of the species, stylizing the pattern on the body and using painted calico in shades of

purple, and red and pink silk to make the creature, using beads and small stitches in metallic thread to add detail.

I decided to keep the background relatively plain, using painted and sponged calico, but adding stitches, small glass beads and gemstone chip beads to give a sense of water movement and life. The piece is hand-stitched and mounted onto Khadi paper that has been painted with indigo drawing ink.

It would be an interesting exercise to depict such a creature on a more involved background, among corals and tendrils of seaweed.

Rainforest

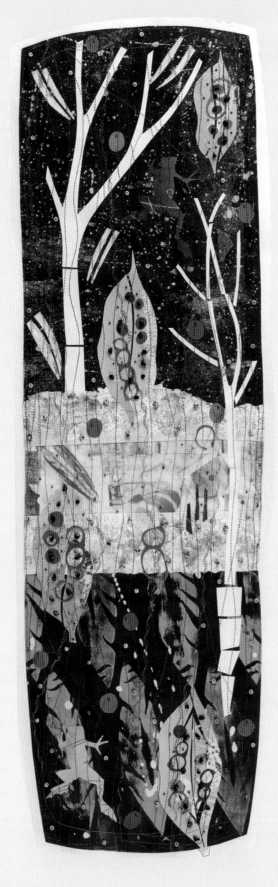

Pods and Frogs
30 x 94cm (12 x 37in)

The rainforest is a subject I first started to use in my textile work several years ago. I enjoy the plethora of amazing plants, animals, birds and insects that are indigenous to the jungle, and its sheer abundance.

Having never visited a rainforest, many visits to botanical gardens and the photographs taken therein have informed and stimulated my work. Going into the overheated tropical houses, with the dripping of water, beautiful plant structures, glorious leaves and flowers, exotic fruit, the light and shade, the sense of secrecy… all these stimuli never fail to inspire me to make another piece of rainforest-themed work.

If you decide to theme your own work on this subject, you will find no shortage of colour, strong pattern and wonderful creatures to inform your creative journey. You can place your chosen elements on plain backgrounds, as I have in the works *Rainforest I, II* and *III* on pages 80–81, taking care with the arrangement of shapes and the equally important spaces that are created between those shapes. Conversely, there is no need for minimalism; the inherent abundance of the jungle is a wonderful excuse to make a busy and exuberant piece of work, such as the piece on the left, *Pods and Frogs*.

I like to combine black and white with shots of bright colour; the background of *Pods and Frogs* consists of block-printed black paper, and calico which I painted black and spattered with lime green pearlescent acrylic ink. I used the same ink to paint some Khadi paper for the burgeoning, floating pods. The cascading red seeds depict abundance, and using the negative fabric shapes resulting from the cutting out of the seeds adds another layer of interest. The piece also includes digital printing on fabric, and machine-stitching in cotton, rayon and metallic threads. I have added many types of bead, including wooden, gemstone chip and glass.

Evolving the theme

A further two pages from my rainforest sketchbook (shown on pages 26 and 27) can be seen below. You can see the photograph that inspired the leaf design I used in *Rainforest I* (on page 80), and some of the drawings and collage work I made when I was playing with various ideas.

I decided to restrict the colour scheme to predominantly black, white, green and red for strong graphic impact, an idea which came directly from this photograph of leaves in a botanical garden.

I chose black felt as the background for each piece, with the bold simple shapes cut from painted and printed calico, and painted silk. I also used some commercial printed and metallic fabric in *Rainforest I*. Using a simple shape such as this leaf in a limited mix of materials can produce a strong and coherent piece of work, and it is always enjoyable to choose and manipulate the shapes and materials.

Each piece is finished with machine-stitching in a mix of threads, with some straight stitch and a limited colour palette of beads and pearls to embellish. They are edged with white acrylic painted calico, with machine-stitching on these borders attaching them to heavyweight Khadi paper.

Below, pages from my rainforest sketchbook.

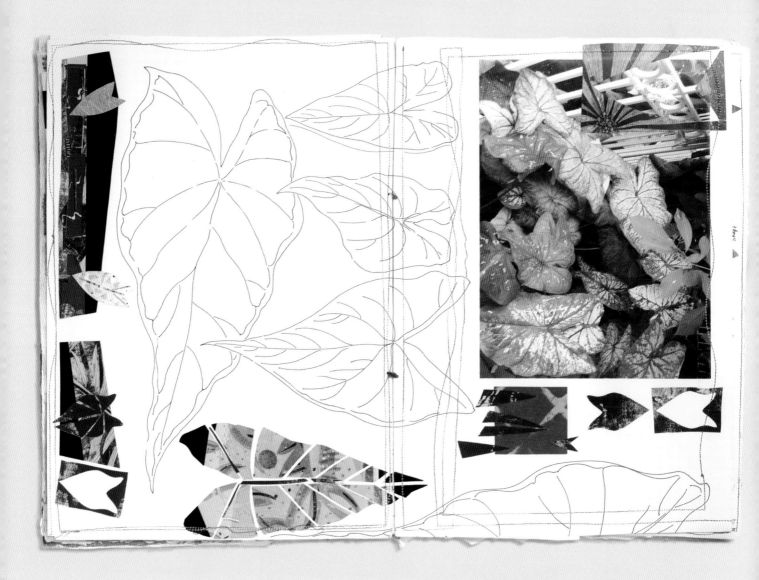

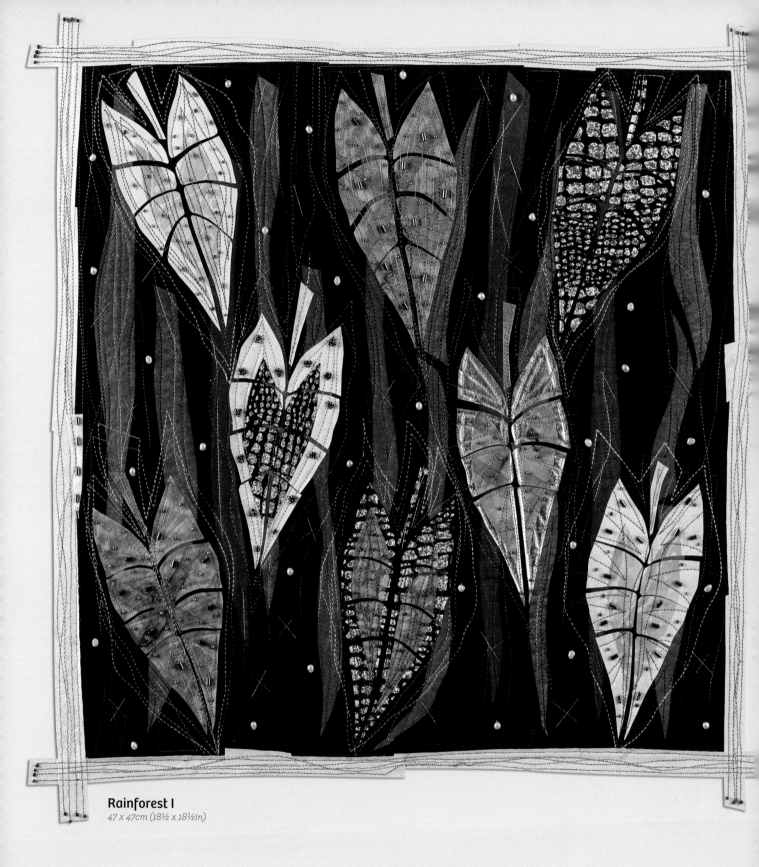

Rainforest I
47 x 47cm (18½ x 18½in)

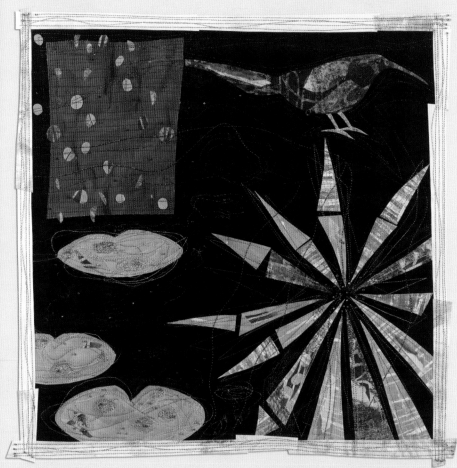

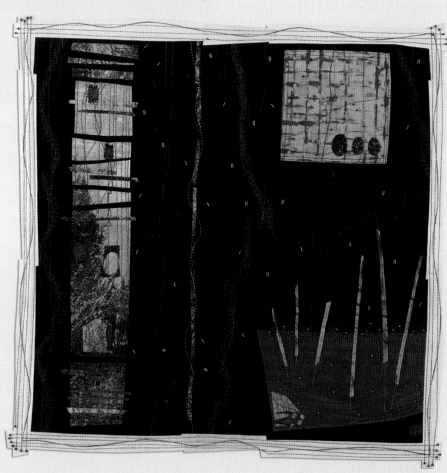

Rainforest III
47 x 47cm (18½ x 18½in)

81

Artists' books

An artists' book is a work of art in book form, which can take on many structures, and be made in many materials; it can relate closely to a traditional book structure, or move the general concept of a book beyond the usual experience of the form, to amazing levels of creativity and ingenuity. A variety of rich and exciting formats can be used, from more recognizable book constructions to sculptural pieces and objects that the artist regards as a book, designing and working through a process of cognitive and emotional interpretation.

Scarabs
78 x 30cm (30¾ x 12in) when unrolled
Hand embroidery and beads on felt, with silk organza edging.

The scroll book is backed with appliquéd and hand-stitched black cotton and is tied with a beaded cord.

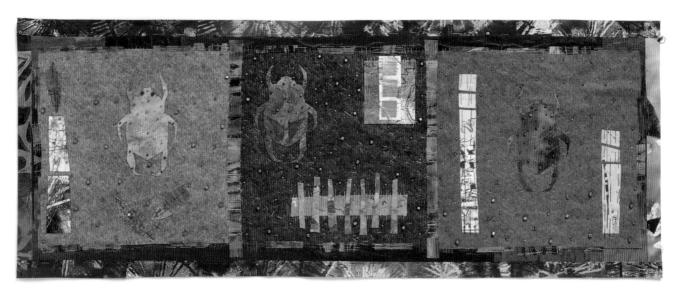

Scroll books

Inspired by Indian, Chinese and Japanese scroll books, I find this a fascinating format to work with. Scroll books can be viewed horizontally or vertically, and can be as small or as lengthy as you like.

I have split one of my lengthy scroll books into three parts, but I also enjoy making smaller scroll books which are more intimate and accessible. A theme-based scroll book, showing a collection of images; a scroll book which displays a subtle unfolding of narrative; a scroll book made from densely hand-stitched rich fabrics, or a scroll book containing text you have chosen or written – this is a format which intrigues and offers a contained freedom of expression.

I love the idea of a travelling collection of precious stitched textile scroll books, unrolled to reveal their secrets, then being carefully rolled again to continue their travels.

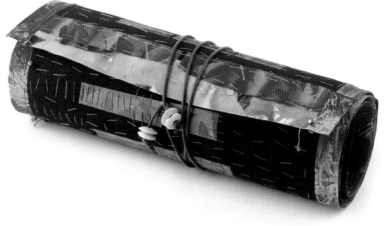

In 2009 I made my first artists' book, *Into the Cacao Grove*, and have since made an additional fourteen books, some of them quite large – *Into the Cacao Grove* itself measures 90 x 56cm (35½ x 22in), is 8cm (3¼in) in depth and weighs 12kg (26½lb). All my artists' books have been made using fabric, paper, mixed media, machine- and hand-stitch. I write my own text for the books, and have produced artists' books in a number of different formats: bound, boxed, hanging, scroll, shaped books and folded, or concertina, books.

My artists' books are 'uniques' – they are each one of a kind. They are both an object and an experience, describing a subject, an idea, a thought process, a life, using, in my case, a narrative of words and images throughout their pages. There are many artists' books on the internet, and many variations within each format, and I would urge you to spend a little time looking at the vast variety on view.

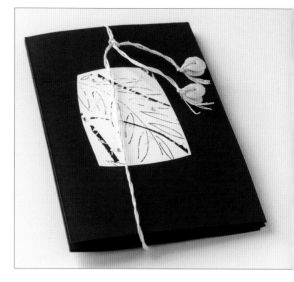

Above and below

Spring Night
77 x 21cm (30¼ x 8¼in) when unfolded

When adding stitched textiles to a folded book I generally stitch the pieces separately and glue them on when finished, which is what I did with the piece on this page, *Spring Night*. It is made from sheets of printed and painted calico, hand-stitched and embellished, which are mounted onto digitally printed paper. These are then mounted onto black folded card. When the book is folded, a small stitched image is visible, and a simple twisted cord ties the whole piece together.

Folded books

Also known as concertina, zigzag and accordion books, these books tend to be smaller in scale so are an excellent introduction into the world of artists' books. They are also some of my favourite books to make, as they can be made from a vast range of materials. You can construct a simple folded book from sheets of sturdy paper or strong card; your material simply needs to be easy to fold and crease, and strong enough to stand without buckling. Adding layers of collage will strengthen the structure too, and your book can be any length you like.

You could also use separate pieces of thicker card to make a bigger book, and hinge them together with glued fabric strips.

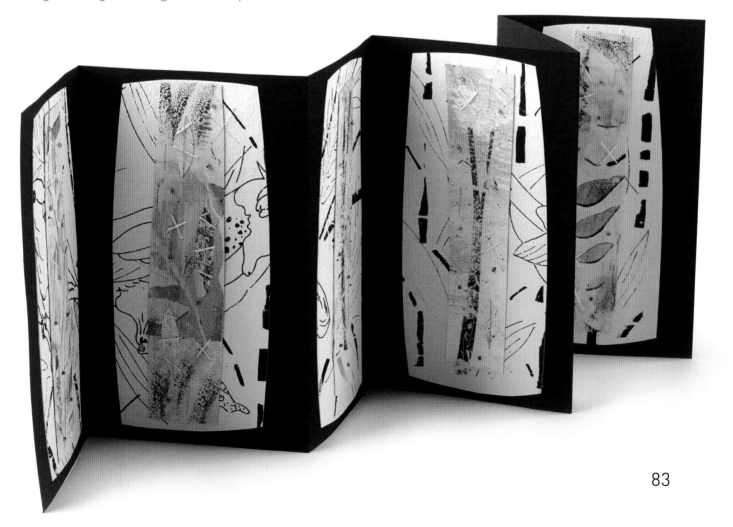

Butterfly Scroll Book

This small hand-embroidered scroll book showcases three butterflies, made from digitally printed fabric, and mounted onto felt. I enjoy using felt as it doesn't fray, and is easy to stitch by hand.

I printed small pieces of white cotton on my inkjet printer, from some images I had produced using some of my photographs and image manipulation software. It's certainly not necessary to use digitally printed fabric for this piece; any fabric and background combination that pleases you will work.

To achieve a strong graphic look, I chose black, white and cream as my colour scheme, with cream and black metallic thread and red thread and beads as a contrast. You can choose any number of fabric combinations for this project, from subtle soft colours to flamboyant bold and colourful combinations. Organza butterflies would work well too.

Materials

Black felt measuring 57 x 11cm (22½ x 4¼in) for the background

Cream felt measuring 59 x 14cm (23¼ x 5½in) for the backing

Calico for the butterflies: 20 x 15cm (8 x 6in), printed by hand (see pages 52–56) or digitally (see page 57)

Fusible web, 57 x 11cm (22½ x 4¼in) for the reverse of the background

Fusible web, 20 x 15cm (8 x 6in) for the butterfly fabric

Embroidery threads: white and black hand-quilting cotton, black and silver mix metallic thread, thicker red embroidery thread (such as perle cotton, size 5).

Black velvet cord, 80cm (31½in) to tie around the book

Red and black seed beads

Four flat beads to tie on to the cord

Tracing paper

Templates (see page 124)

Equipment

Pencil and eraser

Fabric scissors

Iron and surface for ironing

Sewing needles

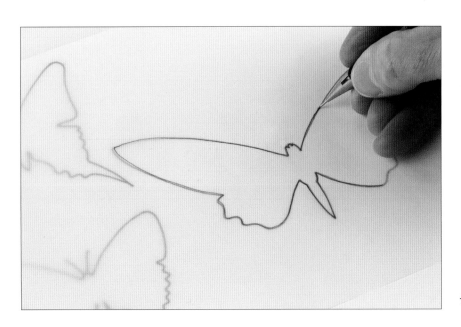

1 Trace the three butterfly templates from page 124 onto tracing paper.

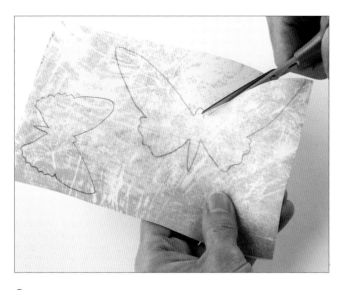
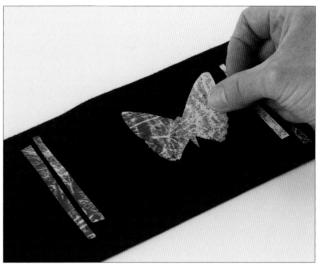

2 Apply fusible web to the reverse of your printed butterfly fabric. Transfer the butterfly shapes to the paper backing and cut them out. Then, working freehand, cut out eight uneven slivers of fabric, which will be positioned either side of the three butterflies.

3 Position the strips of the calico and the butterflies on the length of black felt. The butterflies do not need to be perfectly central between the strips but allow space for plenty of hand-stitching around the butterflies themselves.

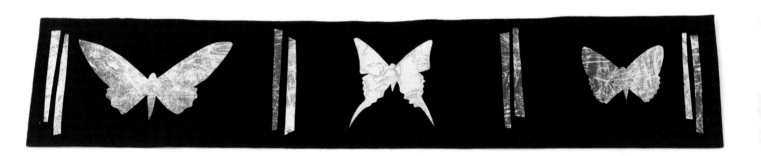

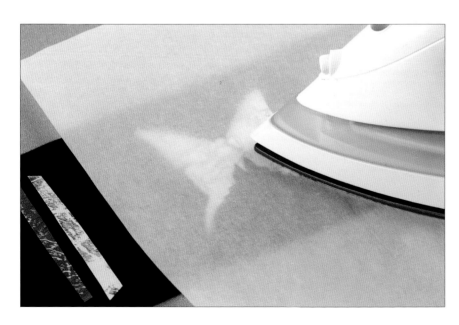

4 Once you are happy with the positioning of your butterflies and calico strips, place a sheet of fusible web over the piece and iron the shapes into place. Work on a heat-resistant surface such as an ironing board or mat.

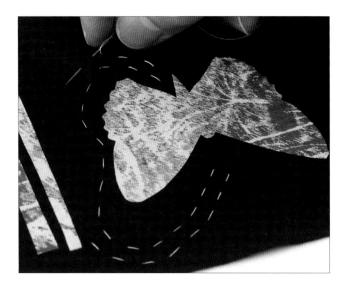

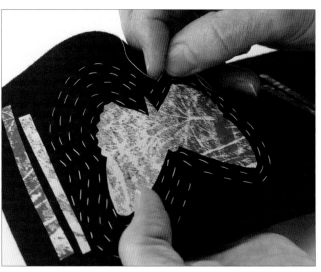

5 Begin to hand-stitch the piece with white cotton thread, using straight stitches in various lengths to surround the butterflies. Avoid stitching too close to the edges of the black felt as you may wish to trim the edges before you fuse the black felt to the cream felt at step 10.

6 Surround each of the three butterflies evenly with straight stitch in concentric patterns, as far as – but not over – the strips of calico.

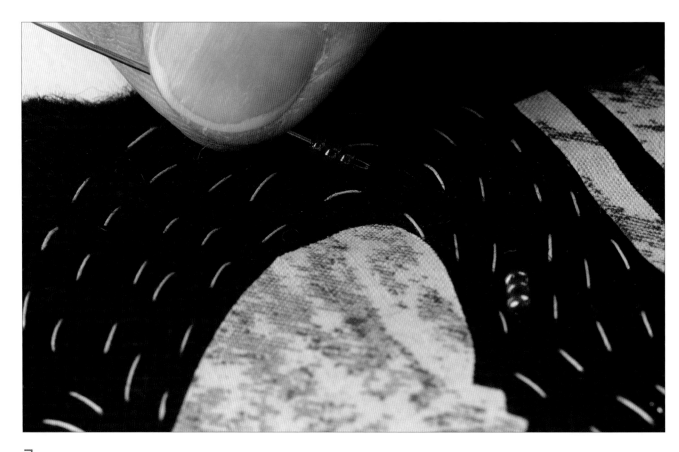

7 Switch to black cotton thread, and have to hand plenty of red seed beads. Sew individual beads at regular but well-spaced intervals around the central butterfly, between the white stitches, and groups of three beads at regular, well-spaced intervals around the left- and right-hand butterflies.

8 Decorate the butterflies themselves with medium-length straight stitches in black and silver thread at irregular angles as you see fit. Intersperse the stitches with individual blue metallic seed beads. Sew on two beads at the tips of the butterflies' heads to represent their eyes.

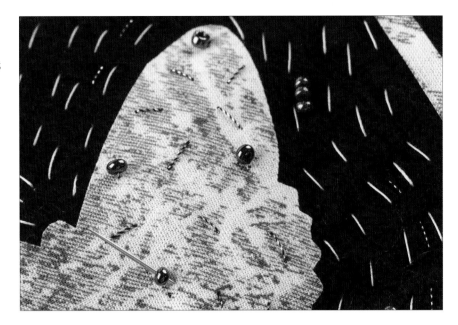

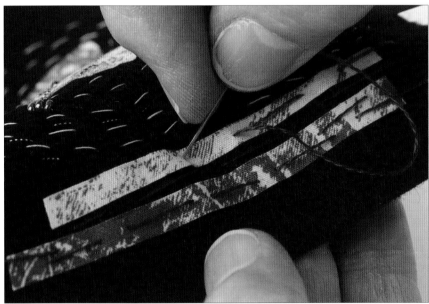

9 Thread a sewing needle with red embroidery thread and with long, straight stitches sew over, and between, the strips of calico either side of the butterflies. Your stitches can overlap onto the black felt for a more organic look.

10 When the stitching is finished, apply fusible web to the back of the black felt. Using a padded ironing surface will cushion the beads and help the web go on smoothly. If the edges need trimming, this is the time to do it. For felt, I find a rotary cutter and straight edge work best for achieving neat edges. Position the black felt neatly on the cream felt, then, again using the fusible web, attach the two lengths of felt together.

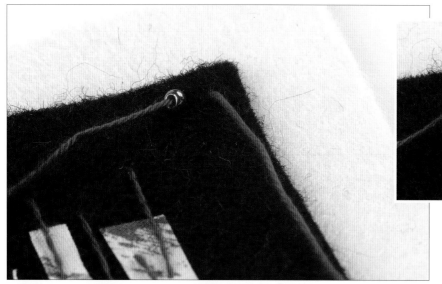

11 Thread a length of the red embroidery thread to the back and then through to the front at each of the four corners of the black felt, now fused onto the cream felt. Attach a single red seed bead to the thread coming from the reverse of the felt, and tie the bead in place with a knot. Trim the ends of the thread to even lengths. Repeat this three times along the two long edges of the black felt, above and below each butterfly, and at the centre at each end.

The finished scroll book
59 x 14cm (23¼ x 5½in) unrolled

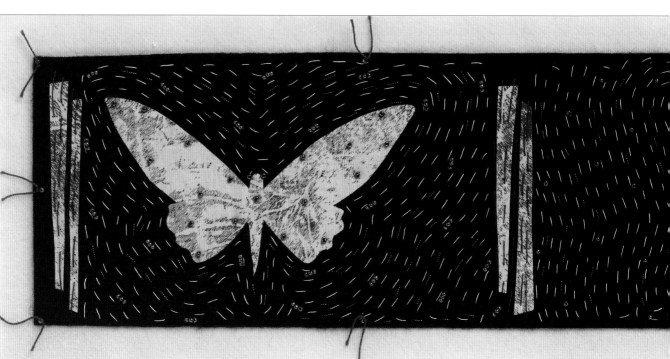

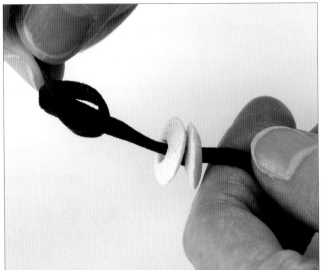

12 Thread two flat beads at either end of the length of velvet cord and fasten in place with a tight knot. Roll up your scroll book from one short end to the other, and wrap the cord around it to seal the book and complete.

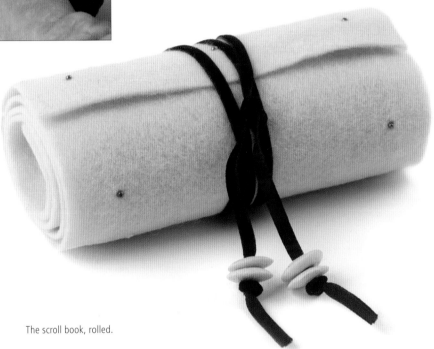

The scroll book, rolled.

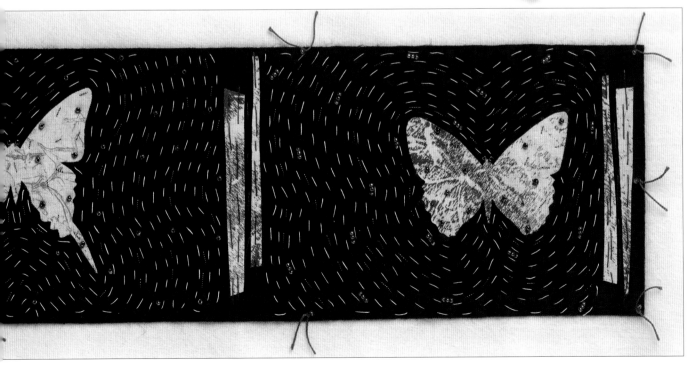

Botany

The variety of plant life on Earth continually astonishes and thrills us. Not only are plants essential to our existence, they also provide a myriad visual stimuli and creative possibility for artists.

I have used plant life in many of its forms in my work for the whole of my artistic career; it is my natural creative home, shared by many other textile artists who love the plethora of botanical subjects with which we coexist.

I enjoy looking at the work of botanical illustrators and at herbals, and have spent many hours drawing plants. My early drawings were very detailed, but I now want more freedom of expression, so I choose not to represent the botanical subjects in my pieces in a totally realistic way.

You can stylize your own subjects as much as you wish, adding, subtracting and arranging your compositions to create your vision. You could explore the symbolism of plants, or produce work based upon a favourite flower, woodland or tree, as a one-off piece or a series of investigative works. I have also seen successful and personal works that have been based on a particular garden throughout the seasons. Buds, flowers, leaves, root systems, bulbs and rhizomes, plant structure and the life cycle of plants are also fascinating areas to explore.

Visiting, drawing and photographing gardens, hedges, botanical gardens with their range of glass houses, forests and farmland will start you on your journey to collecting images you can use in your work, and of course more exotic locations can provide some amazing material.

Details from Leaves

Leaves is based on one leaf shape which is repeated across the piece using digitally printed papers, silk organza and metallic fabric. Using one or two shapes in this way and placing them on a background is a very effective technique, enabling the use of a variety of materials, changes in scale if you wish, and the use of the negative shapes left after the elements have been cut out.

I enjoy using a patterned background, as the juxtaposition of both plain and patterned elements creates some very lively pieces of work. This piece has a background of digitally printed Khadi paper, and is finished using machine-stitch, hand-stitch and gemstone beads.

Opposite
Leaves
28 x 41cm (11 x 16in)

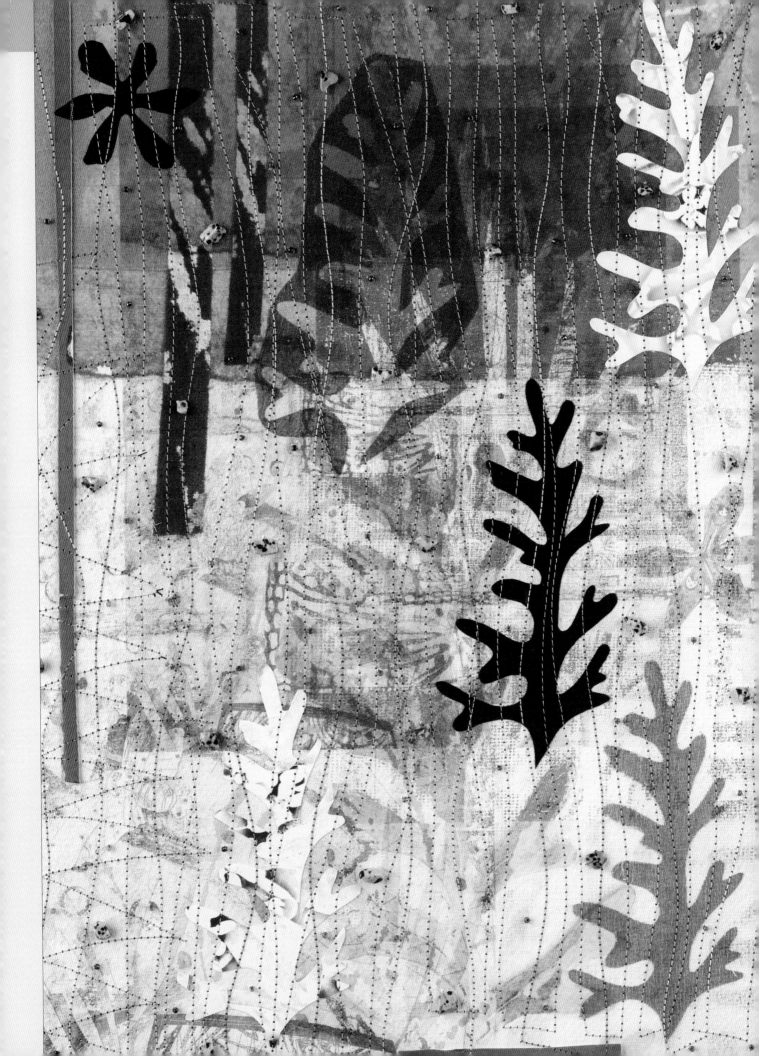

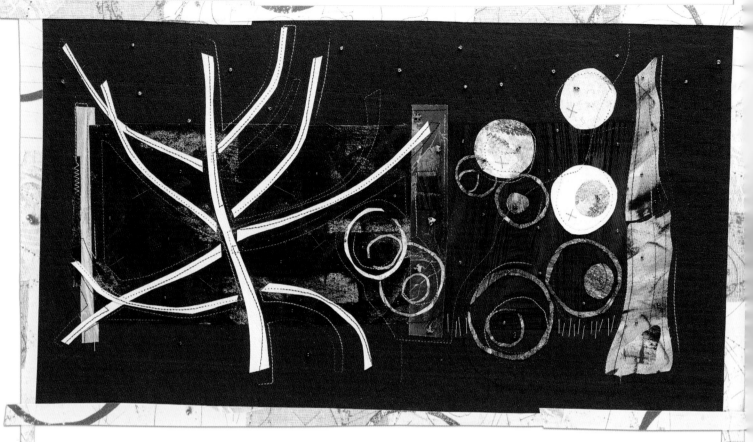

Winter Garden, Night and Day
72 x 56cm (28¼ x 22in)

These two finished pieces are both variations of the work demonstrated in 'Developing a design', pages 58–65. The works have been similarly developed from the sketchbooks on pages 24–26, drawings and collages. The works employ two different colour approaches to explore both night and day in a winter garden.

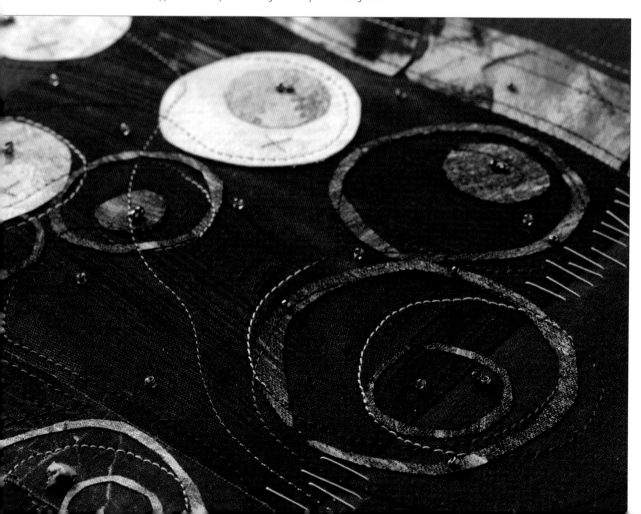

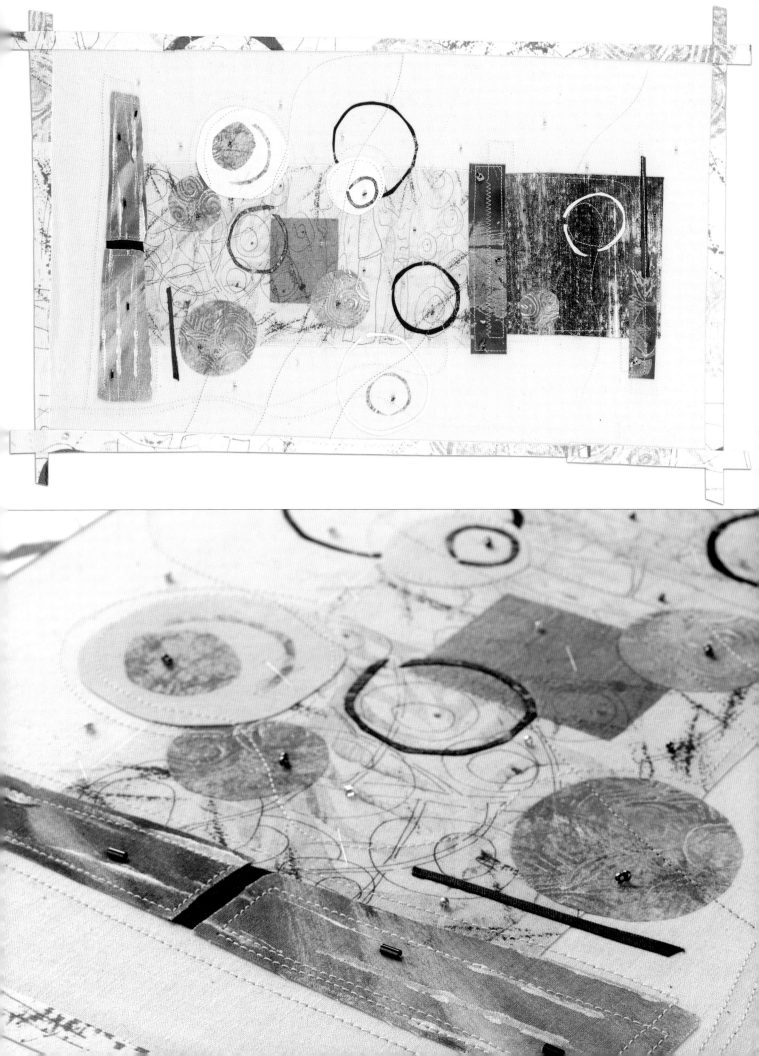

Birds

When I look back through my work, both textile and ceramic, I am always surprised by how many birds it features. It wasn't until I made my artists' book, *The Stone Bird*, that I realized quite how important they are to me.

The book was to be based upon fossils and a variety of aspects of the natural world, but an image of a fossil of an *archaeopteryx lithographica* changed that. I had a strong emotional response to this creature, which is possibly the oldest known fossil that is generally accepted as a bird. This made me want to celebrate its descendants in all their wonderful variety, and thus, the book became centered upon birds. Featuring integrated text and image, fabric and mixed media in its sixty-four pages, it is quite a hefty tome weighing 12kg (26½lb), and measuring 80 x 58cm (31½ x 23in).

The birds I see in our garden and countyside are extremely important and life-enhancing, and many are represented in the book, but I do love exotic birds too, for their amazing colours and shapes.

Ravens, from The Stone Bird (artists' book)
80 x 58cm (31½ x 23in) each

These two birds were cut out of a quilt that I had begun but not completed: this is a good reason not to thow any of your work away!

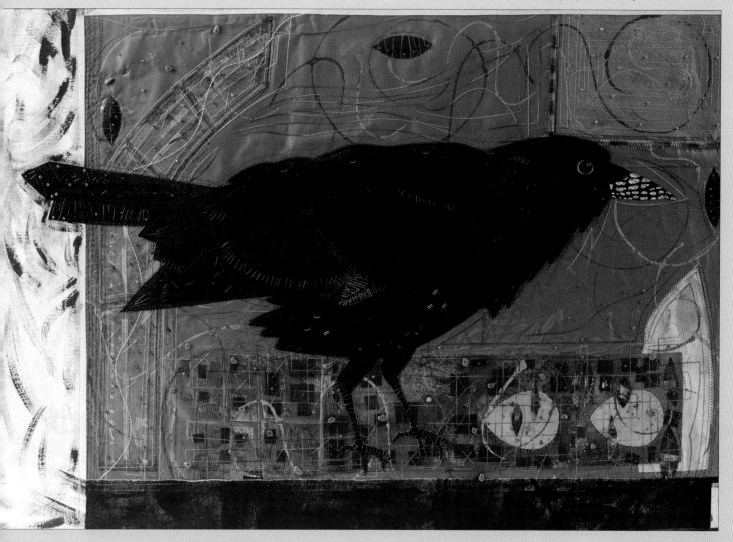

If birds appeal to you as a theme, start by undertaking some enjoyable research: take photographs of birds, refer to books and the internet and watch television programmes to find out which species pull your creative strings. You can represent the birds in a faithfully accurate way, or tweak them slightly, using a basic bird shape but stylizing and simplifying feathers and other features.

Another device I enjoy using is to cut out the shape of a bird from patterned fabric, perhaps layering on a few feather and wing shapes, letting the fabric do the work. This method works well for depicting repeated patterns in a piece of work or showcasing some favourite fabric. You can see this technique used in the *Book of Birds* project on pages 98–107 and in *Rainforest II* on page 81.

Try using a range of tiny bird shapes in an image- or pattern-based piece; experiment with different fabrics and backgrounds to achieve a more lively, or calmer, piece.

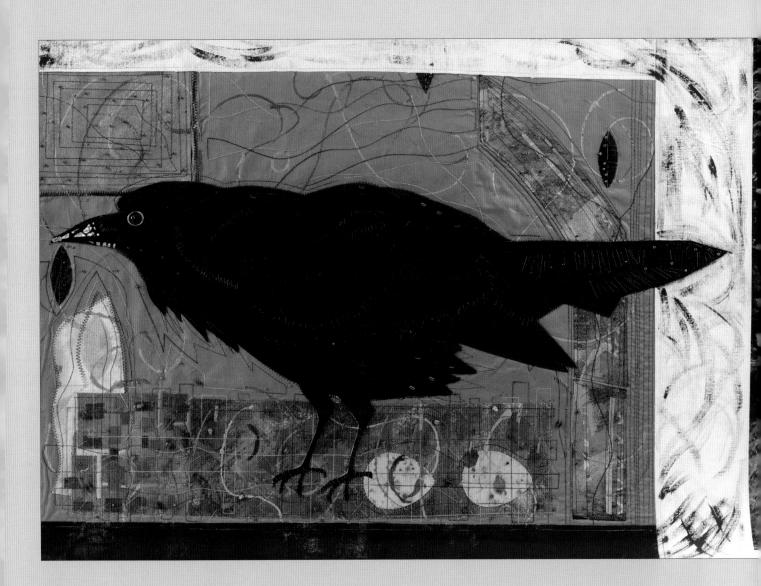

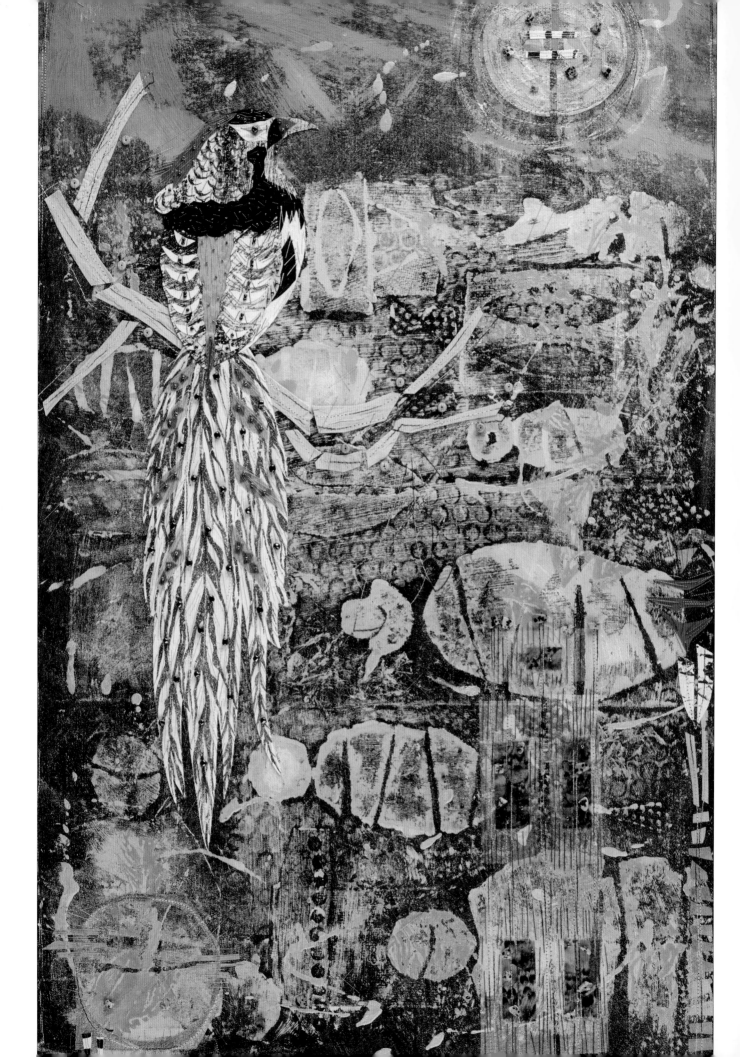

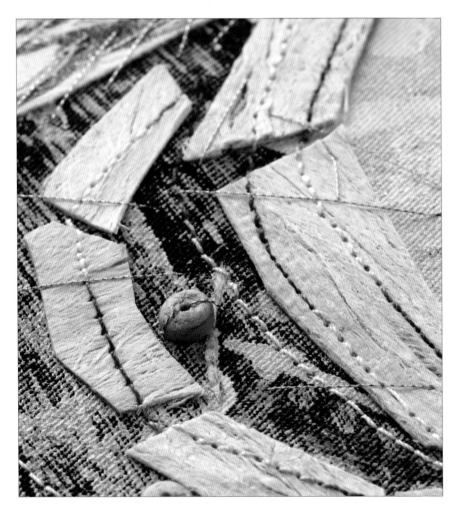

Top left

I made the pheasant from layered, painted calico, which I then embellished with hand-stitch in a mix of metallic threads and white thread, and beads of varying sizes.

Top right

I chose commercial metallic gold fabric to make the sun, and added machine-stitch in variegated black, yellow and white thread, then added gemstone chips.

Left

I made the branch from collaged pieces of mulberry bark fibre, which has been machine-stitched with black and white variable thread and hand-stitched with metallic thread. I then added some small wooden beads.

Opposite
Light and Shade II
41 x 63cm (16 x 24¾in)

I see nothing wrong with using a subject more than once if you like it and want to exploit its potential. This piece is based upon a Lady Amherst's pheasant, and I have used it in three pieces of work, including the cover of *The Stone Bird*. It is quite intricate and took a while to construct on its complex and lively monoprint background.

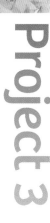
A Book of Birds

This small hand-embroidered bound book features six brightly coloured birds, with flowers and foliage made from a mix of fabrics and mounted onto paper to form the pages.

This project shows you how to make up one page of your book (although the materials are recommended, below, for all six pages), and bind the book together.

Materials

Tracing paper – approximately 29.7 x 21cm (11¾ x 8¼in)

Six 20 x 15cm (8 x 6in) sheets of 320gsm (140lb) Khadi paper, or sturdy watercolour paper, at least 300gsm (140lb)

Six pieces of background fabric, each measuring 16 x 12cm (6¼ x 4¾in)

Six 5 x 4cm (2 x 1½in) pieces of matching fabric for the small decals

Six pieces of fabric 14 x 3.5cm (5½ x 1½in) for the page edges/spine, with fusible web applied

A mix of small pieces of fabric for the birds, details on the birds, flowers and foliage (I used painted silks and silk organza) – all backed with fusible web

A piece of white cotton, 30 x 25cm (12 x 10in), backed with fusible web

Fusible web, at least 30 x 50cm (12 x 20in), enough to cover the back of the fabrics you choose for the birds, leaves and flowers, and the page edges

Threads: variegated metallic thread, green metallic thread, red metallic thread, green variegated 6-ply fine cotton thread

Small beads to match your colour schemes

Templates (see pages 125–126)

Equipment

Fabric scissors

Iron and ironing mat

Sewing needles

Glue stick and good-quality PVA glue, or heavy-body gel medium

Bradawl and foam board

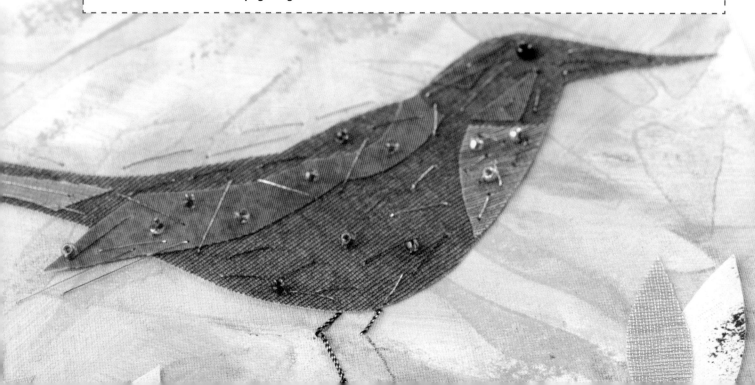

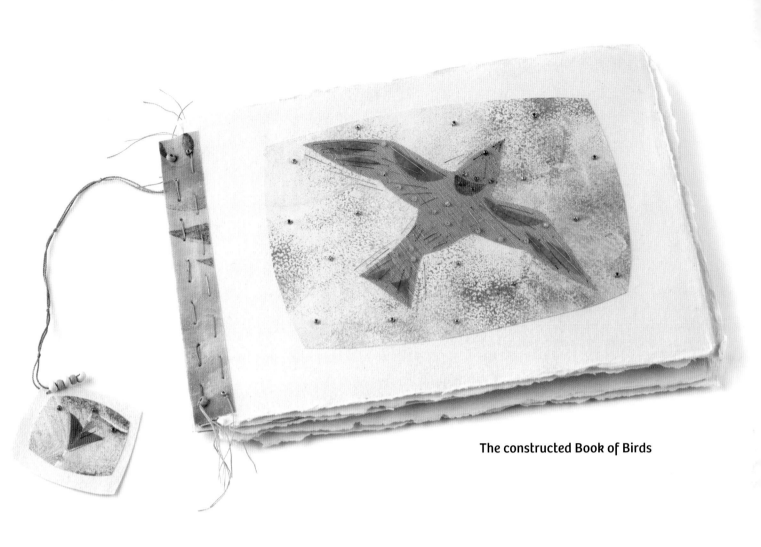

The constructed Book of Birds

1 Trace the outline of the bird and the elements of the bird separately, or photocopy them. Set the pieces aside.

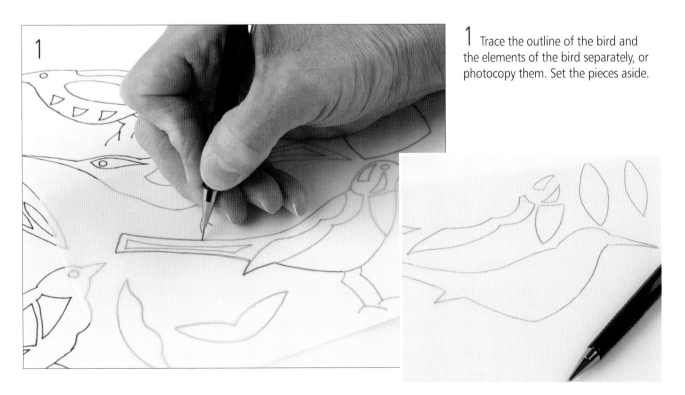

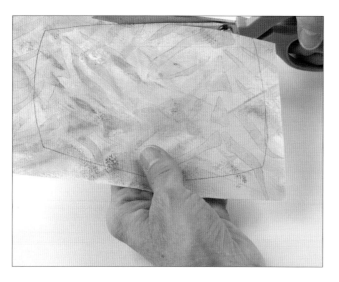

2 Choose the background fabric for your page – in this example I have used calico that I have painted and printed with a leaf motif. Cut the shape of the page (the larger curved-edge rectangle from the template on page 126) out of the calico. Cut the smaller rectangle (from the template on page 126) out of the same fabric; this will be used as the small decal.

3 Fuse the pieces of silk for the bird's body and body details to the white cotton. This will make them sturdier and easier to handle, and will also make them opaque. Silk that is not treated in this way may merge into the background when ironed in place. Place a piece of parchment over the silk when you iron the silk to the cotton.

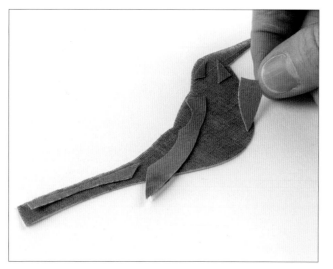

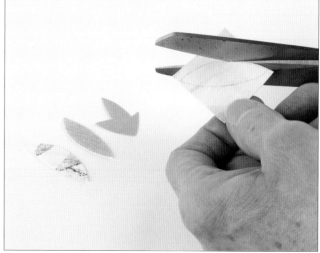

4 Cut out the traced bird shapes from step 1 from the silk. Cut the details of the bird out of contrasting fabric from the bird's body, then assemble your bird as you would like it to appear on your page. Set the bird aside.

5 Choose fabrics for the leaves and flowers that will appear on the background of the page, and on the opposite page to the bird; trace the shapes from the template on page 126 and cut out the small shapes.

Tip

Layers of paint can make calico quite stiff, so you may not need to apply supportive fabric or fusible web to the calico used in step 2. If you choose to use lighter-weight fabric, you may need to back it with cotton or thin interlining attached with fusible web.

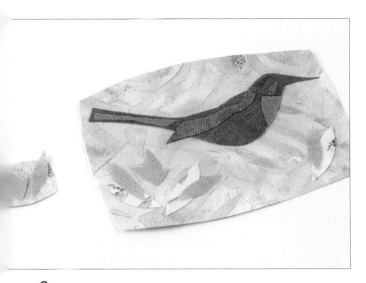

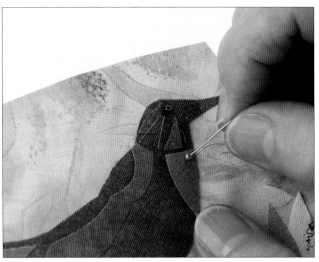

6 Position the bird with some flowers and leaves on the page background in a pleasing arrangement. Do the same for the small motif. Iron the pieces in place, with a sheet of baking parchment between the design and your iron to protect the work.

7 When the motifs are ironed into place, begin to sew on the beads, and apply stitch to decorate your page. Begin by stitching on a small black seed bead for an eye, then embellish the bird's face with long straight stitches. Stitch small gold seed beads onto the bird's breast and embellish the area with smaller stitches.

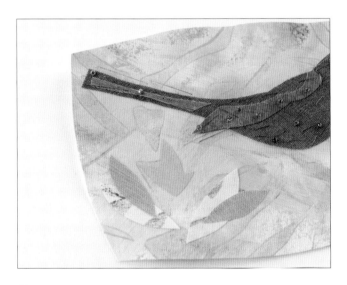

8 Continue to stitch over the bird and sew on beads to define its shape, right up to the tip of its tail and wing. Sew red seed beads onto the bird's upper wing.

9 Sew the bird's legs as simple straight stitches using a double strand of black metallic thread. Use a single, extra stitch to pull the lengths of the legs into curves as shown.

Once you have embellished the bird, sew over the leaves in green metallic thread, roughly follow the shape and direction of the leaves. Enhance the leaves and flowers by sewing on tiny seed beads in complementary colours.

Tips

At this stage of the project I have used purely straight stitch of various lengths, sewn quite freely to complement the shapes of the bird, and the leaves and flowers. I have made the stitches by hand, but feel free to use a sewing machine if you prefer.

At step 9, if you do not feel confident stitching the bird's legs freehand, draw guidelines in pencil first.

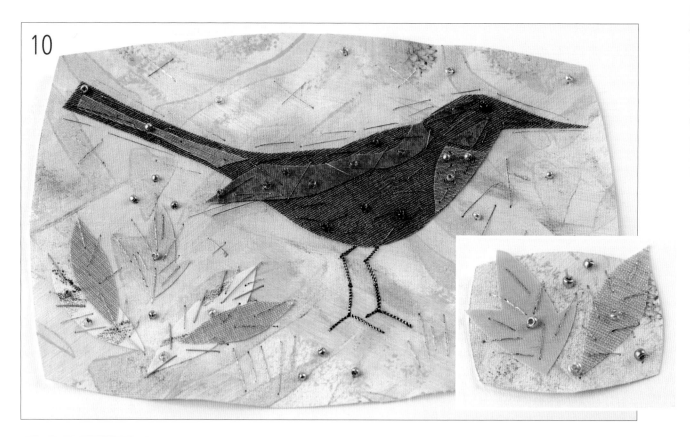

10 Once you are happy with the amount of stitching and bead embellishment on your bird page, make similar stitches in matching variegated and metallic threads over the smaller motif (inset) that will sit on the left-hand page facing your bird. Set these elements aside while you bind your book.

11 Edge the page with a 4 x 14cm (1½ x 5½in) strip of painted, printed fabric (see template on page 126) with fusible web applied. Fold the fabric strip in half width-wise, and slot it around the short edge of the Khadi-paper page.

12 Iron the fabric in place along the page edge, keeping a sheet of baking parchment between the page and the iron to protect it. At the same time, iron or glue your bird decoration to your paper page to the right of the spine.

Note

Your accompanying motif can be ironed onto the left-hand page facing your bird page once the book is bound, at step 16 on page 103.

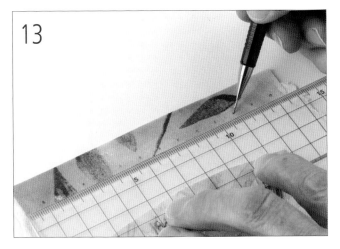

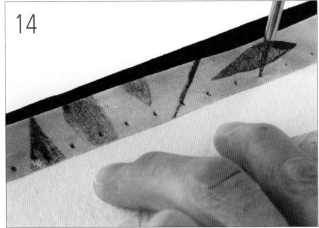

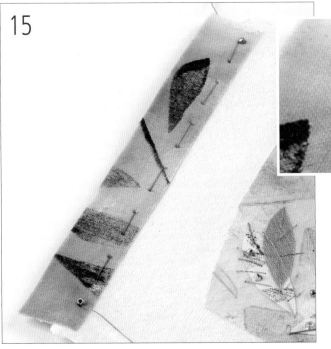

13 Make pencil marks along the inner edge of the fabric using a ruler to keep the marks even at 1cm (½in) intervals. This is where your book will be bound.

14 Place foam board underneath the Khadi-paper page. Then, using a bradawl, make holes along the inner edge of the fabric, following the pencil marks made in step 13.

15 Choose a cotton thread in a complementary colour and thread it in and out of the holes made with the bradawl. You can also attach a small bead at either end of the stitching (inset).

> **Note**
>
> *If you have created multiple pages for your book, this is the point at which you can begin to bind them all together.*

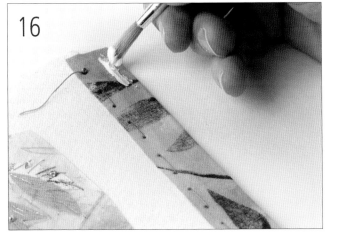

16 Stack the pages in the order in which you would like them to appear as a bound book, then glue the outer edge of each fabric spine using heavy-body gel medium.

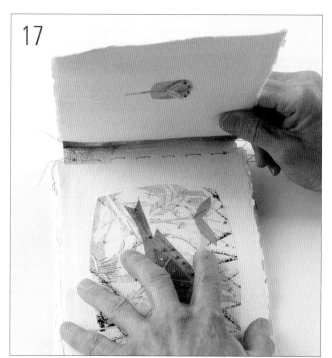

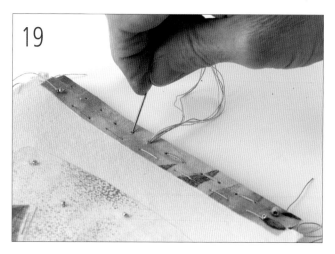

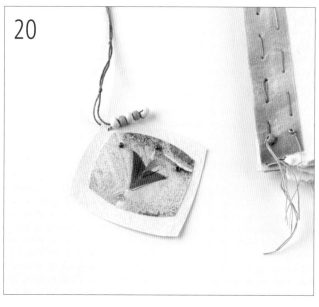

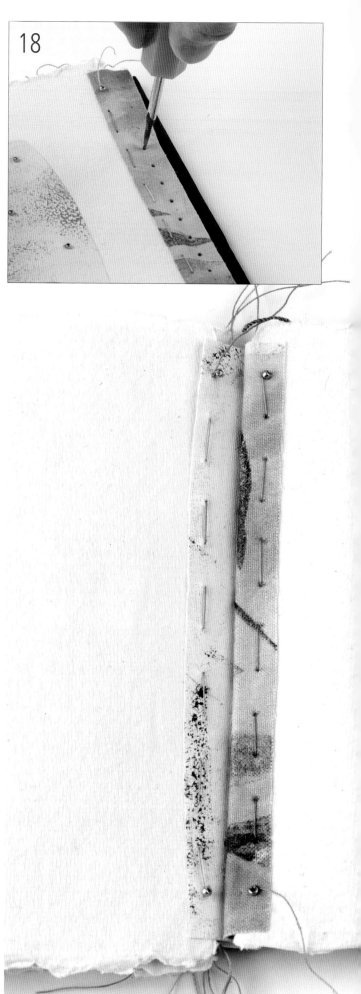

17 Carefully re-stack the pages to stick the fabric spines together, one on top of the other. Clipping three clothes pegs along the spine may help keep it together as the glue dries.

18 When your book is dry, use the bradawl to push thirteen holes into the outer length of the spine, making sure the bradawl goes through all of your pages. Keep the holes roughly 1cm (½in) apart.

19 Stitch through the spine with three strands of thread. This type of binding is strong, and allows your book to be opened flat. Thread beads at either end of the spine to give an attractive finish to the book.

The finished page and accompanying motif

Look overleaf to find some ideas for further pages of your own *Book of Birds*.

20 If you have fabric, thread, beads and papers left over, you could make a small decorative tag or bookmark for your book, using the small, rectangular template for the motif (found on page 126) attached to thread. Tie your tag to the book by knotting the thread into one of the loops of thread on the spine.

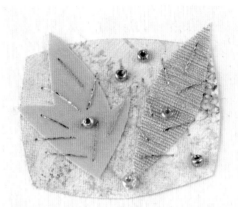

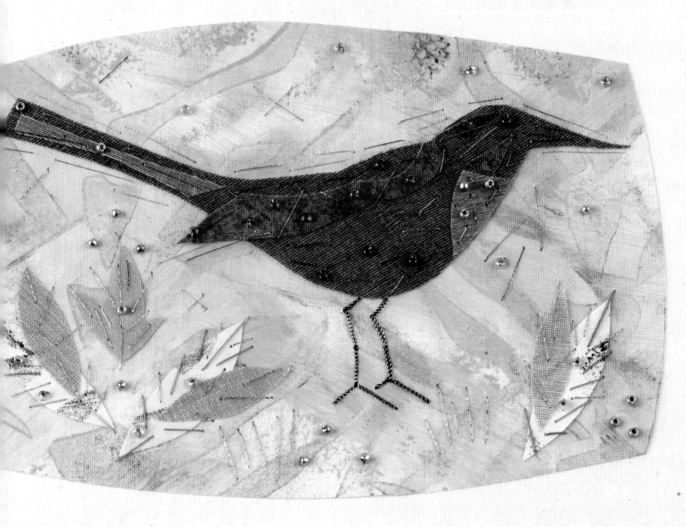

A Book of Birds
22.5 x 15cm (8¾ x 6in)

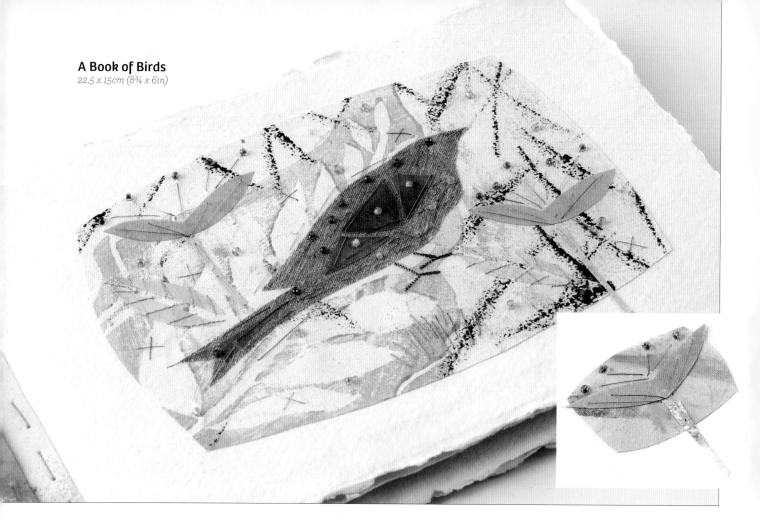

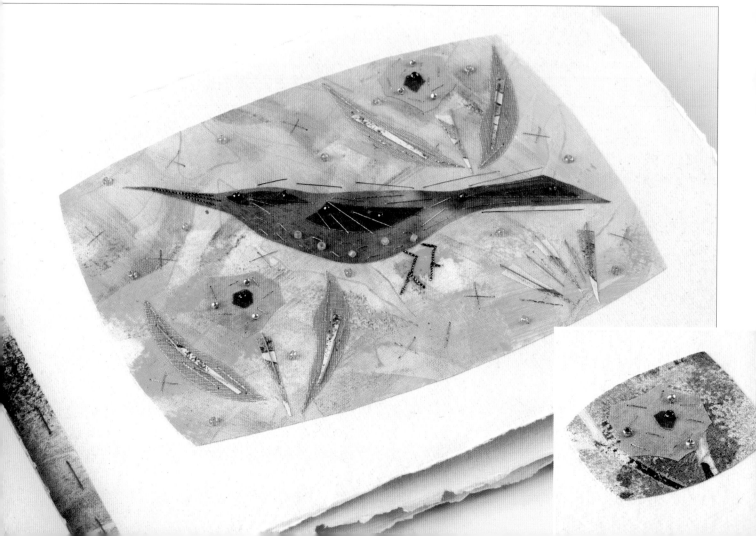

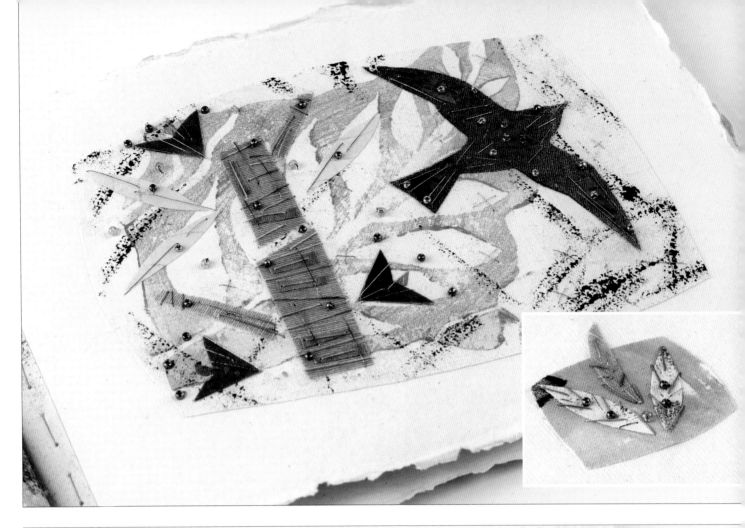

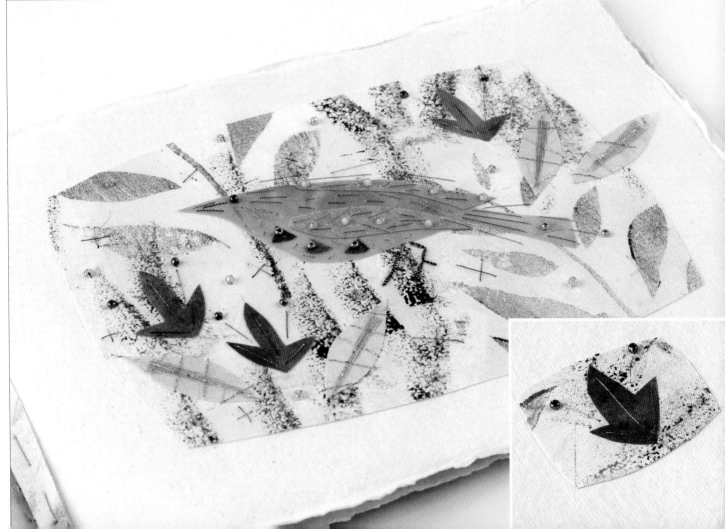

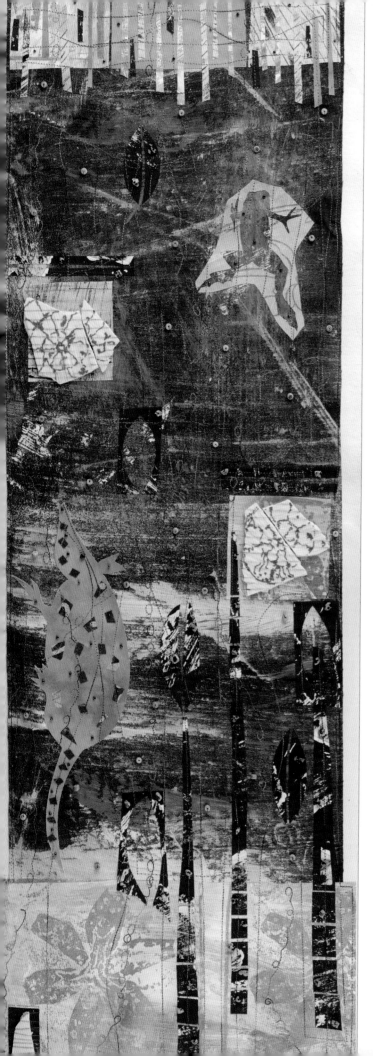

Animals

Mammals – from wild animals to pets – and reptiles with their fascinating shapes and patterning are a marvellous resource of ideas for the textile artist. You could simply use the shape of the creature, as I have with the rhinoceros piece on the opposite page, using different fabrics or papers. Other animals whose shapes would work well in this way are antelopes, cats, horses and camels; in short, animals with a strong, recognizable form. The mythology and symbolism surrounding various creatures could also be a starting point for a work themed around animals, which could happily develop into a series of work or an artists' book.

Pattern is one of my interests, and there is a plethora of amazing animal pattern out there: think of a zebra, a giraffe (the shape of which is also great to work with) or a leopard. A piece of work featuring simply the shapes and the patterns in a mix of fabrics would create an astonishing piece of work, and does not have to be true to life regarding colours either. Why not employ vibrant blues and greens in a design based on the patterning of a giraffe's skin?

Texture is another aspect that you may wish to explore. I tend to work with pattern and shape, but I have seen some wonderful texture produced by my students, using a range of thicker fabrics such as tweed and fake fur. You can also add layers of machine- and hand-stitch to build up texture, and the illusion of texture can be obtained by using printed fabrics.

Armadillo
31 x 94cm (12¼ x 37in)

This piece features another of my favourite animals: the armadillo. During my career in ceramics I made many armadillos; here I have used the creature's unmistakable shape, decorated with painted silk shapes and beads. The negative shape of the frog that was cut out for the *Pods and Frogs* work on page 78 was used in this piece too.

Flat, broken porcelain pieces painted with ammonite patterns are stitched onto the painted black cotton background that dictated the colour scheme for the whole piece.

Rhinoceros

27 x 53cm (10¾ x 21in)

Arranging shapes to form a pattern or image-based composition is an enjoyable approach to creating a work. Juxtaposing different materials, especially those you think would never be successful together, can produce some stunning work. Pick some patterned fabrics and place them together to liven things up; I do this to prevent myself from making staid and safe choices.

For this rhinoceros piece, I used some African indigo-dyed cloth that I had wanted to employ for some time. I kept the edges of the cloth offset, which tied in with the liveliness of the running rhino motif. I combined the background with some appliquéd painted calico in the negative shape of the rhinoceros, machine-stitched the piece and completed it with large turquoise beads.

Tiger, tiger

I have found that throughout my career as an artist, certain animals reappear in my work on a regular basis. You too may find that there will always be those subjects and stimuli to which you constantly return, and in turn they will continue to inspire new work, based upon the knowledge you have acquired whilst working with them in the past.

I can trace my interest in tigers from one of my first stitched pictures made as a teenager, of three tigers' faces. Then, when I made ceramic animal sculptures during my years of working with clay, tigers were one of my favourite subjects.

I chose to use an image of a magnificent tiger's face to develop some digital pieces, a folded book (below, right), and the appliquéd machine- and hand-stitched felt and painted calico piece seen on pages 112–113. This repetition of the tiger-face motif demonstrates the wide range of approaches that the textile artist can take to a theme, beyond relying solely on fabric, scissors, needle and thread.

Beginnings

I drew the tiger's face, below, in black fine-nibbed artists' pen and felt pen. I scanned this into my computer and digitally altered the image, producing a range of images that I then printed onto canvas paper. I also used this drawing as the basis for the fabric piece on pages 112–113.

A concertina book

I used and manipulated the original tiger image to form this concertina book, constructed from Khadi paper. Firstly I painted and block-printed the book using inks. The digital images were layered with other digitally printed papers, and machine-stitched. I added beads before gluing the pieces to the book.

The concertina book is 112 x 19cm (44 x 7½in) unfolded.

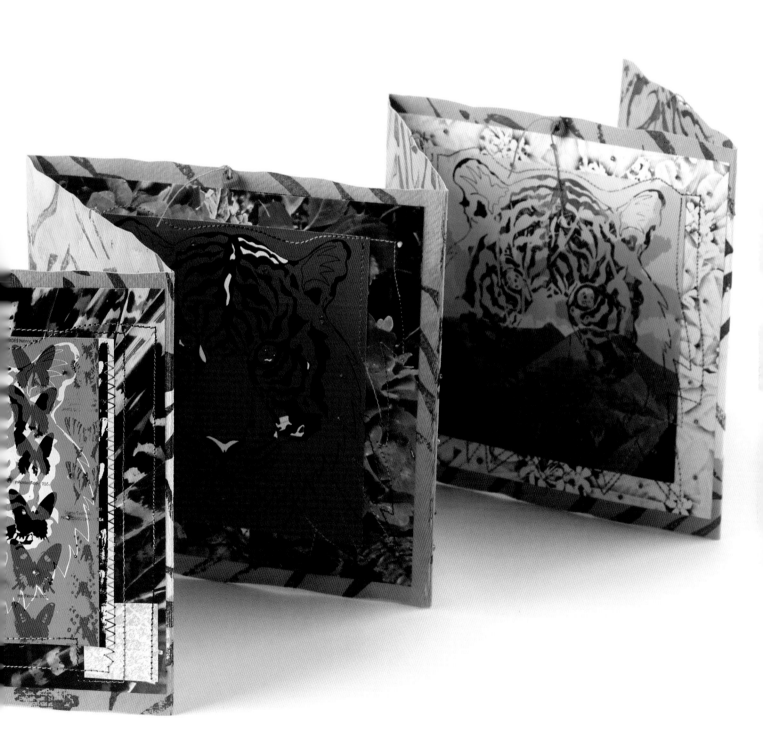

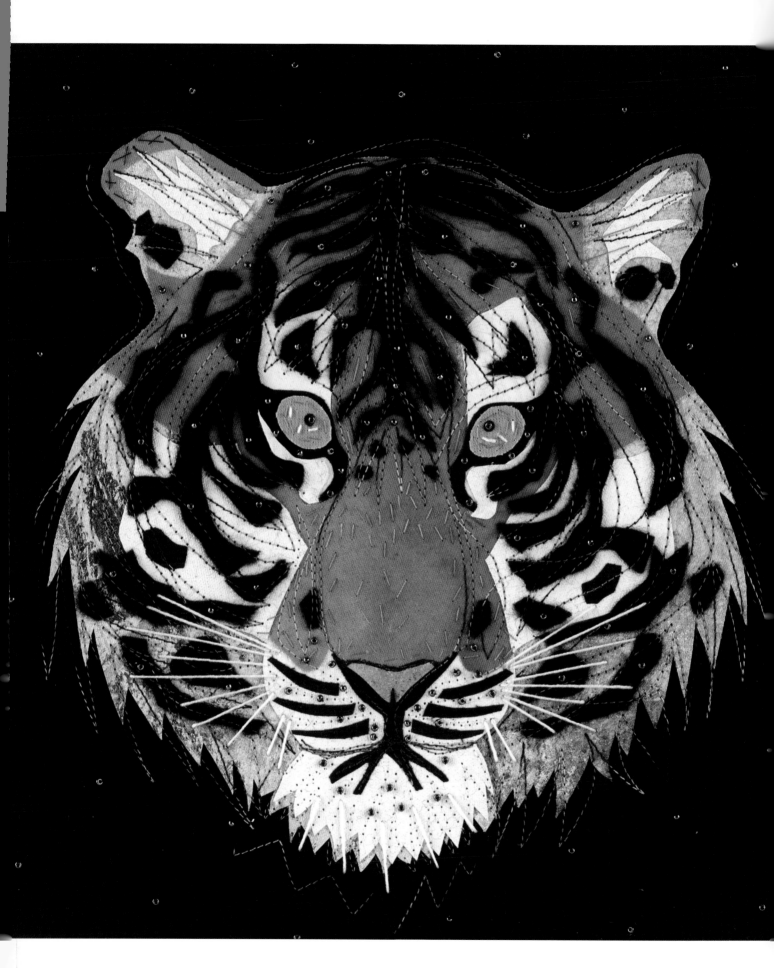

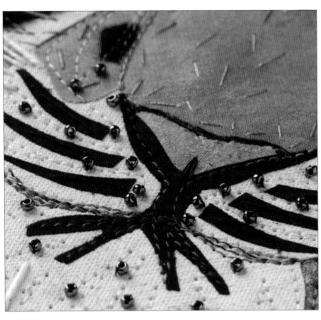

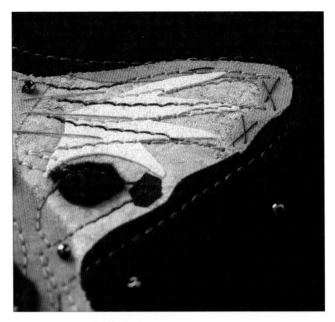

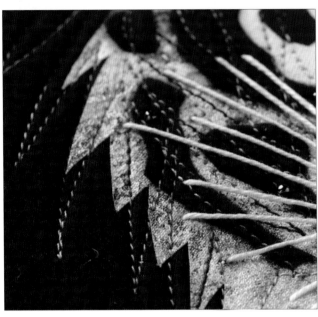

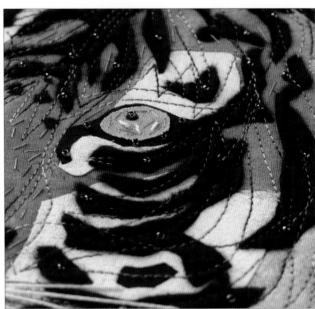

There was a quantity of intricate cutting out involved in making this fabric version of the tiger; patience was definitely needed. I layered painted calico onto black felt and used the same felt to create the stripes. I machine-stitched the piece using variegated cotton, and added detail with some hand-stitching and beads.

Tiger
26 x 27cm (10¼ x 10¾in)

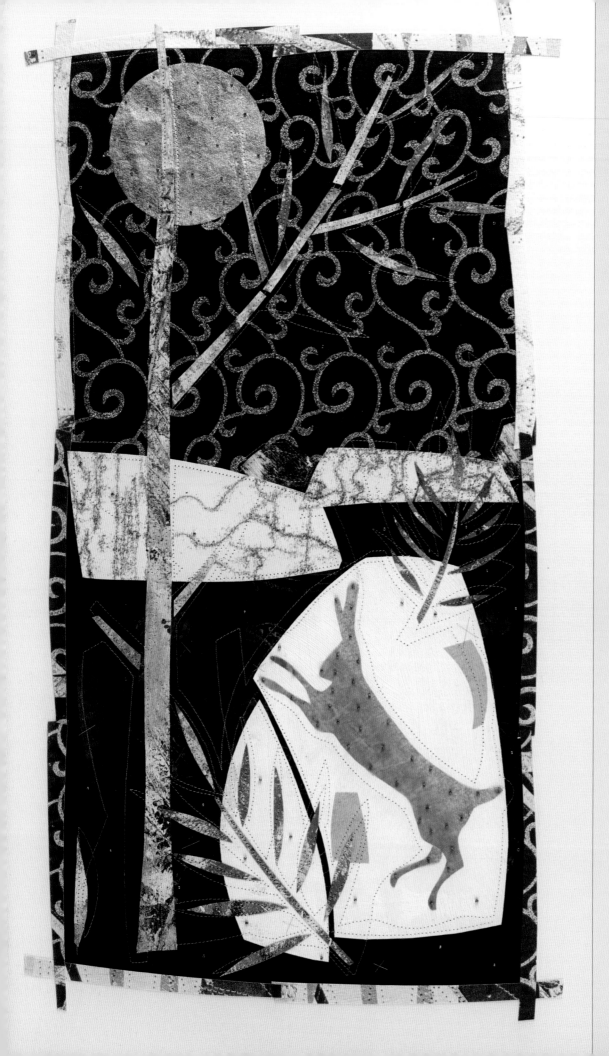

Dancing Hare
61 x 91cm (24 x 35¾in)

Dancing Hare

The springtime sight of female and male hares boxing provided the inspiration for this piece. Following on from this, the fact that they are mostly nocturnal creatures prompted me to place this hare under a full moon, where it then appeared to be dancing. Nocturnal animals seem to occupy a completely different world, which is both foreign and fascinating.

The bold silver patterned fabric is man-made organza. The tree, landscape and ferns are made from paper and painted fabric; the hare is cut from very thin metal fabric, and the moon from silver metallic fabric.

I photographed the finished embroidery and printed a sheet of Khadi paper with some of the close-up images of the embroidery itself. I then cut the Khadi paper into strips to form the border. Strip borders such as this can maintain the liveliness of a piece of work, being more active than a straight edge, which is generally more orderly. This is something else to think about and explore in relation to the finished effect you may want from your own work.

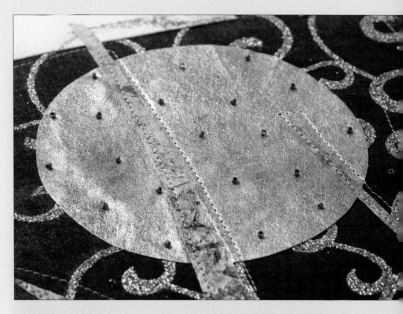

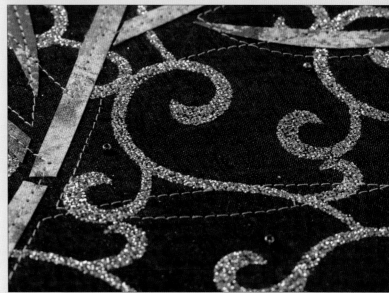

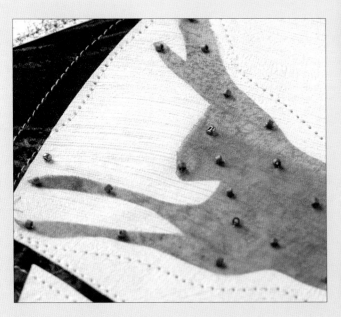

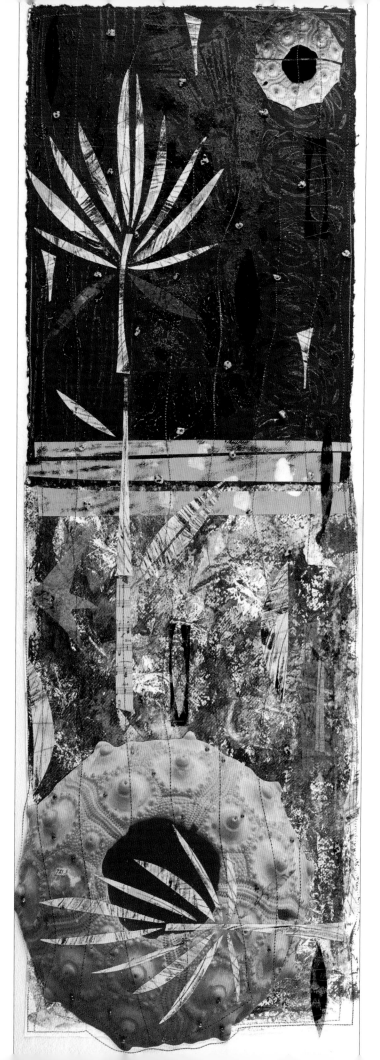

Collections

As a young child who actively disliked school, the nature table sitting in the corner of the classroom was a cheering sight. We were encouraged to bring in anything from seashells, pebbles, leaf skeletons, broken birds' eggs found on the ground and driftwood, to fresh flowers in vases, seasonal fruits or vegetables, acorns, fir cones, sprays of holly, rowan or hawthorn – anything of interest that pertained to the natural world.

Sea Fossil
30 x 92cm (12 x 36¼in)

Sea Fossil is a piece based on an echinoid fossil I photographed in a natural history museum.

The large and small images of the fossil are digital prints of the photograph on Khadi paper, stitched onto a background of painted and printed paper. Appliquéd fabrics have been added, and the piece is embellished with gemstone beads.

I started my own, small natural history collection when I was quite young, and have continued to this day. Seashells, pebbles and dried starfish and seaweeds featured strongly at first, followed by a small collection of very old birds' nests, some deceased moths, butterflies, beetles, and a glorious dragonfly who features in much of my work. All of these were found objects and creatures. I added some bones – mostly sheep vertebrae and the tiny skulls of birds and mice – crabs' shells, various dried pods and an exquisite tiny spherical wasps' nest, paper-thin. Later, I added fossils and gemstones to the collection.

I am still inspired by objects from my little collection, and turn to it frequently in my work.

Magnolias
70 x 30cm (27½ x 12in)

This piece is made from digitally printed calico. The images are taken from a photograph of a magnolia in my garden – altered using a filter in an image-editing program – and a photograph I took of butterflies in a natural history museum, also altered using filters. The piece is appliquéd, machine- and hand-stitched, and the border is made of mulberry bark.

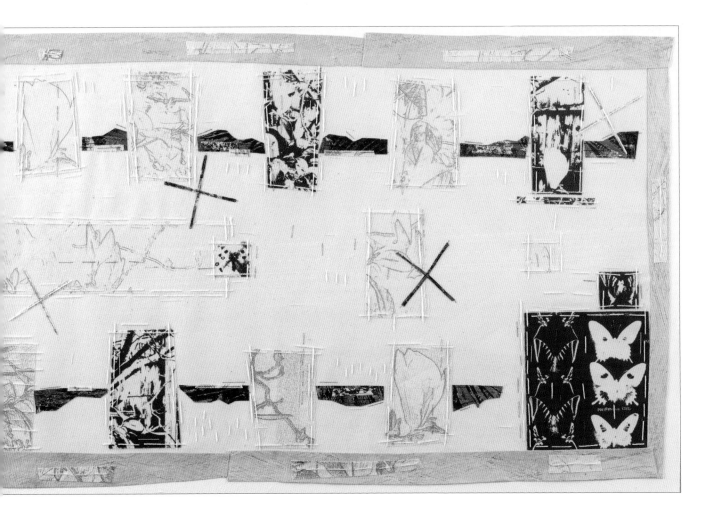

Found

I thoroughly enjoy visiting natural history museums and viewing their collections. The range of articles and specimens in some of these collections is vast, and I appreciate the variety of ways in which the collections are displayed, from glass cabinets to old, pull-out wooden drawers, from free-standing dinosaur skeletons to those portrayed in flight. I have taken many photographs of these collections, and they continually inspire me. I also appreciate that many collected specimens are very old, and may not have been collected in ways that we would find ethically acceptable nowadays. This is regrettable, but I hope that my work celebrates these creatures in life and in death.

I have worked with natural history collections for many years, and amongst other pieces using this theme have produced a series of work entitled *Nature Table* and another series entitled *Found*, which includes the boxed books shown on these pages. This theme also informed a series entitled *Natural Histories*, which also includes the piece shown on page 116, entitled *Sea Fossil*.

Found
Box dimensions: 39.5 x 30 x 9cm (15½ x 11¾ x 3½in)
The *Found* box contains two chain-bound books.

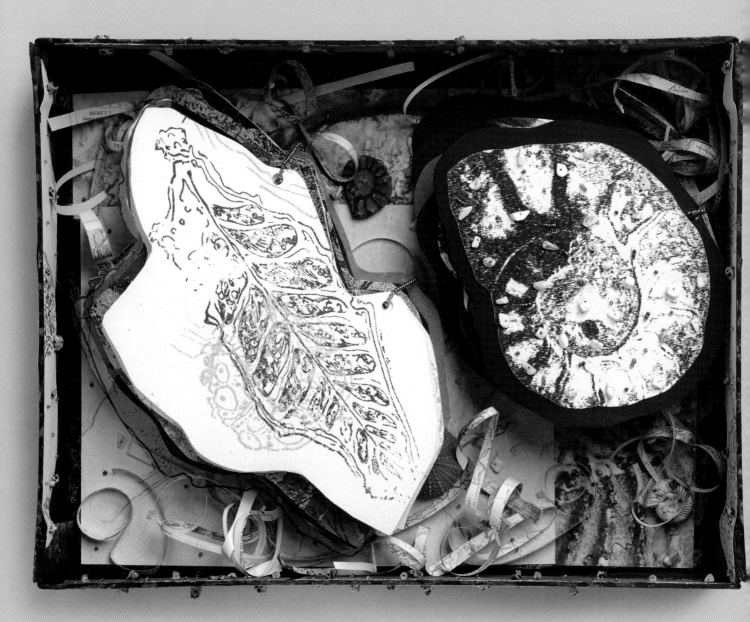

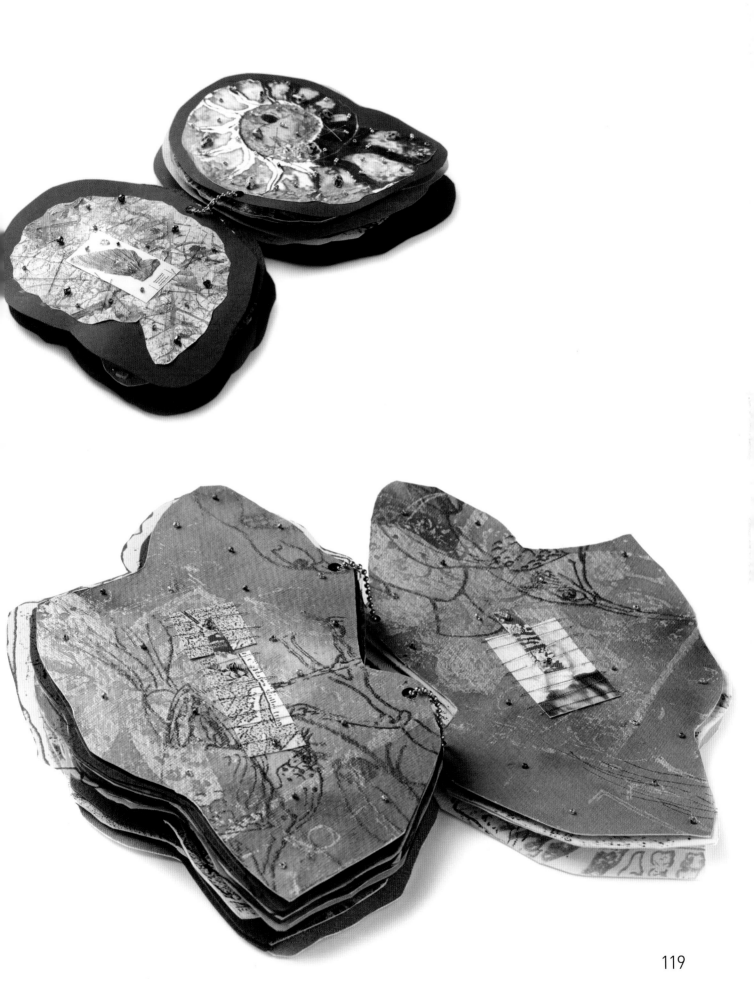

Collection

This final piece, my artists' book entitled *Collection*, continues my involvement with the natural history theme. Each piece is mounted on a 30cm (12in)-diameter circle of Khadi paper; the finished pages have been bound together using two cords passed through the pages and tied up.

There is no text in the book, only stitched mixed-media illustrations, and each right-hand page was first block-printed using a handmade block with silver acrylic ink.

The cover, shown below, was created in the same way, and features an echinoid, or sea urchin shell, that I have made from painted calico and embellished with beads to describe its surface pattern.

Each of the pages in the book employ a mix of machine- and hand-stitch; the elements (such as the beetles, leaves, dragonfly, pods, butterflies, lizard and nest) were stitched separately and glued to the page upon completion, as Khadi paper isn't easy to stitch through, especially if you are adding a good amount of hand-stitch and beads. To do this I add stiffener to the backs of the elements in the form of an extra layer of fabric, fused together using fusible web and trimmed carefully.

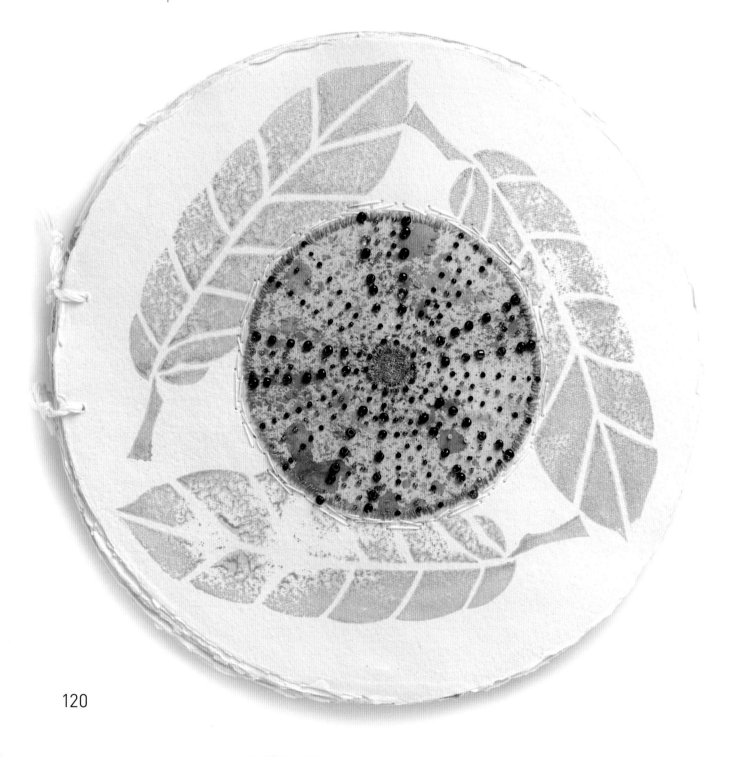

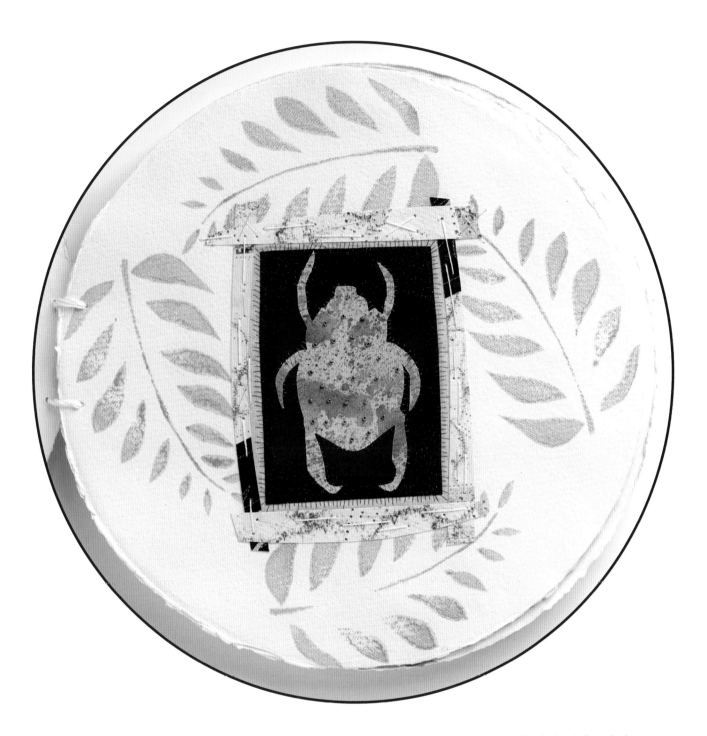

One of the reasons I enjoy working in book form is that a range of designs can be explored and included; you can jump from a peaceful, gentle double-page spread to a more vigorous spread in the same work.

If you have old work sitting in a drawer, it's often a good idea to get it out from time to time and see how parts of it can be inserted into new work.

I always emphasize that there are no rules at all to stitched textile work, and I would encourage you to try out as many approaches as possible. Don't question your ideas, just make them happen!

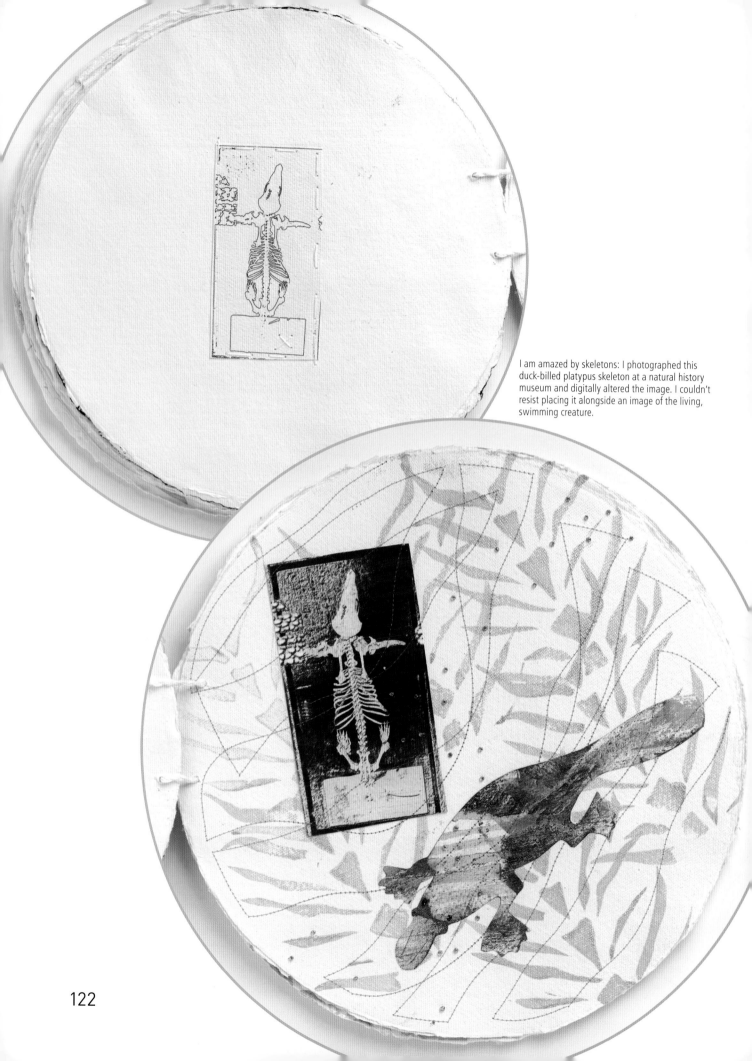

I am amazed by skeletons: I photographed this duck-billed platypus skeleton at a natural history museum and digitally altered the image. I couldn't resist placing it alongside an image of the living, swimming creature.

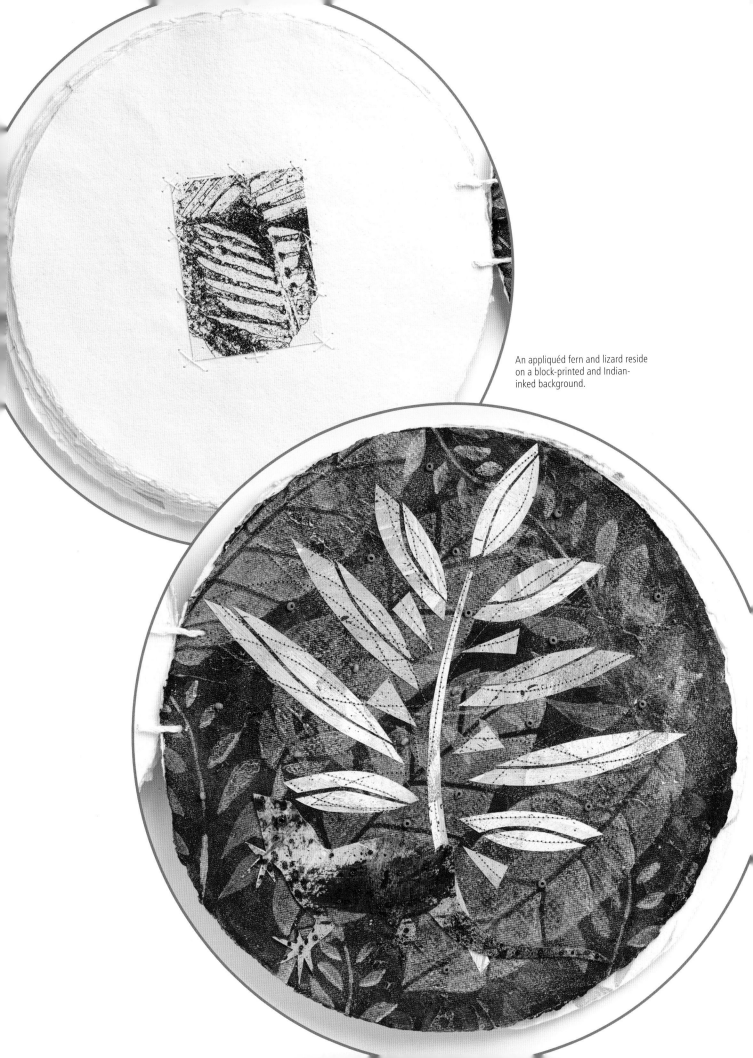

An appliquéd fern and lizard reside on a block-printed and Indian-inked background.

Templates

Templates for *Sea Horses and Starfish*, shown at actual size; see pages 72–76.

Templates for *Butterfly Scroll Book*, shown at actual size; see pages 84–89.

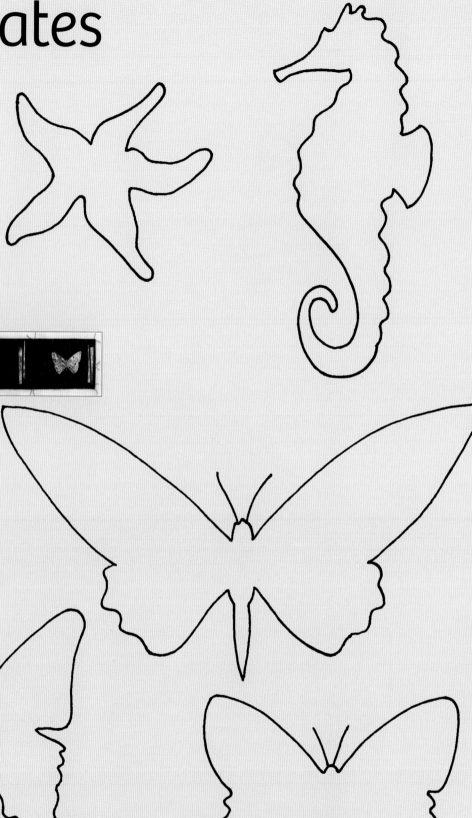

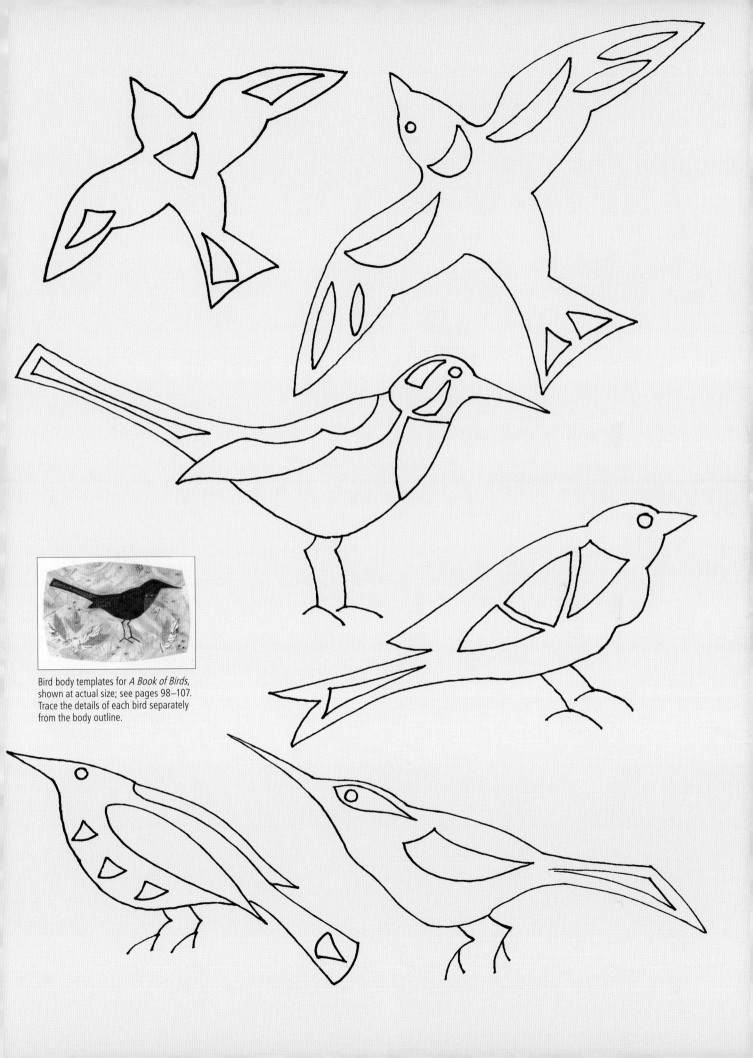

Bird body templates for *A Book of Birds*, shown at actual size; see pages 98–107. Trace the details of each bird separately from the body outline.

Templates for the edges/spines, pages, decals and details for A Book of Birds, shown at actual size; see pages 98–107.

Index

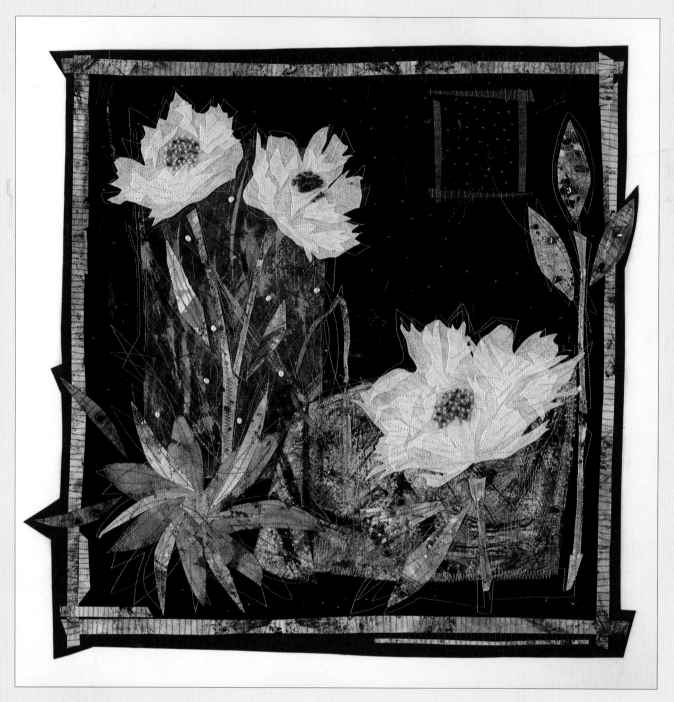

I hope this final piece, and the pieces throughout my book, inspire your own creative journey through the natural world.

Night Peonies
49 x 50cm (19¼ x 19¾in)
Hand-stitched mixed painted and printed fabrics embellished with beads and gemstones.